IMAGES
of America

WEST BRIDGEWATER

ANNUAL RETURN of the names of all the Persons enrolled in the Militia, in the Town of *West Bridgewater* for the year *1848*: the whole number enrolled being *one hundred & seventy eight*.

Noah Whitman, **Town Clerk.**

By the third section of "An Act in addition to the several Acts concerning the Militia," passed March 24, 1840, the Assessors are required annually "to make out a list or roll of all the names of persons liable to be enrolled in the Militia," [*vide* § 1, *chap*. 12, R. S., § 1 *and* 2 *of the said Act of* 1840, *and* § 7, *of the Act of March* 17, 1841,] and place the same "in the hands of the clerk of every city and town in the Commonwealth," in the month of May; and it is made "the duty of every such Clerk," [*vide* § 3 *and* 4 *of the Act of* 1840,] "to record such roll or list of names in the book of record of every such city or town within the Commonwealth," and in the month of May or June, to transmit to the Adjutant General, annual returns of the Militia thus enrolled.

By the tenth section of the aforesaid Act of 1840, the Assessors, or any city or town Clerk, who shall neglect or refuse, at any time, to make the above-named returns, "shall forfeit and pay not more than five hundred nor less than twenty dollars for each and every offence."

George H. Devereux
Adjutant General.

ADJUTANT GENERAL'S OFFICE,

☞ *Every person, liable to enrolment, must be returned without fail.*

NAMES.	NAMES.
Samuel Adams.	Nathan Copeland.
Columbus Alger.	Pardon Copeland.
Cyrus Alger.	Samuel D. Corkins
David Alger.	Jacob H. Crossman.
Edmund Alger.	Peter Dalton,
James Alger.	Adoniram Dunbar,
Joseph A. Alger.	Daniel H. Dunbar,
Leonard W. Alger.	Francis Dunbar,
Sanford Alger.	Josiah Dunbar 2d,
Simeon Alger.	Lucius Dunbar,
Ward Alger.	Martin Dunbar Jr.
William Alger,	Howard Dunbar,
William Ames,	Peter Dunbar,
Ira P. Bailey.	Reuel Dunbar.

All early-19th-century towns had a local militia, and each town required an annual report that included names of its members. This 1840 document lists militia members of West Bridgewater and is signed by town clerk Dr. Noah Whitman, who was also a local physician. (Author's collection.)

On the cover: The official symbol of West Bridgewater is Pulpit Rock located in War Memorial Park. It is said it was upon this rock in 1662 that the Reverend James Keith preached his first sermon. In this photograph, Clara Wheeler Thayer is seated on the rock with her son Joseph, right, and his wife, Maude, left. (Courtesy of Duane Thayer.)

IMAGES
of America

WEST BRIDGEWATER

James E. Benson

ARCADIA
PUBLISHING

Published by Arcadia Publishing
Charleston SC, Chicago IL, Portsmouth NH, San Francisco CA

Printed in the United States of America

Library of Congress Control Number: 2009920585

For all general information contact Arcadia Publishing at:
Telephone 843-853-2070
Fax 843-853-0044
E-mail sales@arcadiapublishing.com
For customer service and orders:
Toll-Free 1-888-313-2665

Visit us on the Internet at www.arcadiapublishing.com

This volume is dedicated to those men and women of West Bridgewater who serve and have served in the armed forces of the United States of America and to the memory of those from this town who gave the supreme sacrifice in defense of our sacred freedoms.

CONTENTS

ACKNOWLEDGMENTS

The undertaking of any project requires the assistance of others and to that end the compilation and writing of this volume would not have been possible without the contributions of the following persons and institutions: Bruce Allen, Carolyn Anderson, Janette Beaulieu, Natalie Beaulieu, Gladys Bergstrom, Dorna Bevis, Susan Cohen Bickoff, Claire Hambly Black, Karolyn Boyd, Brockton Historical Society, Brockton Public Library, Forrest Broman, Richard and Helen Cogswell, Lauri Finch Delaney, Stacey Delorenzo, Cynthia North Donatelli, Easton Historical Society, Greta Edson, Wayne Eldridge, Kenneth Eng, First Church, First Evangelical Lutheran Church, Sharon Fowler, Harvard Law School Library, Vera Haskell, Barbarell Hughes, Jennie Keith, George and Judy Kinney, Jerry Lawrence, Robert E. Lindgren, Jac MacDonald, Ray Mack, Barbara Howe MacQuinn, Nancy Morrison, Marian E. Nelson, Donald Newman, Barbara Ouderkirk, William Panos, David and Diane Perry, Marilyn and David Raleigh, Ethel Rice, Carol Rio, Jonathan Roberts, Robert A. Sigren, Margaret Phillips Silva, Carolyn Keith Silvia, Beth Roll Smith, Stonehill College, Jane H. Taylor, Duane Thayer, Nicole Tourangeau, Warren E. Turner, Andrew Upton, Andrew Vavolotis, West Bridgewater High School, and the West Bridgewater Public Library.

Essential to any project is the support, encouragement, and understanding of family and friends. In this regard I would like to thank my parents, S. Erick and Leah A. Benson, as well as my sister and her husband, Cheryl and Philip Packard, my niece, Corrine Packard-Bradley, Ph.D., and her husband, M. Scott Bradley, Ph.D., and my nephew, Sgt. Christopher J. Packard, U.S. Marine Corps., and Peter L. Borsari and family.

INTRODUCTION

The roots of West Bridgewater go back to those of ancient Bridgewater when that town consisted of what were the north, east, and west parishes and the present town of Bridgewater. This ancient town was a plantation granted to the town of Duxbury in 1645 to compensate it for giving up land to form Marshfield in 1640. The original plantation was divided among 52 proprietors, each with a single share. Later two additional shares were added—one for the Reverend James Keith and the other for Deacon Samuel Edson of Salem, who erected the first mill in the town.

The land in this plantation was purchased from Ousamequin, also known as Massasoit, by Myles Standish, Samuel Nash, and Constant Southworth on March 23, 1649. The purchase price was "7 coats a yard and a half to a coat, 9 hatchets, 8 hoes, 20 knives, 4 moose skins, 10 yards and a half of cotton." This purchase constituted the first inland settlement of the Old Colony. The first house lots were in the west parish, were six acres each, and backed up to the Nunckatesset or Town River. The last section of the town to be inhabited was the north parish, now Brockton. In June 1656, the plantation incorporated into the distinct town of Bridgewater. Then for over 150 years, the town went through many changes in its makeup and civil division. It went through its last change of boundaries in 1893 when sections of the northern part of the town were annexed by Brockton.

West Bridgewater was formally incorporated as a separate town on February 16, 1822. The physical attributes of the town include a good supply of water, as well as rich and fertile soil. The town is traversed by the waters of the West Meadow Brook, the Hockomock River, the Matfield River, and the Town River. Both with adequate flowage, the latter two became major mill sites. On the Town River at what is today War Memorial Park, the first industrial park in America was born with the establishment of the Ames Shovel Works. Also located here in the 1820s was a mill for the carding of wool and another where the wool was made into cloth, carded, fulled, and colored.

Within the town of West Bridgewater there were several villages or districts. While the names are familiar, the origin behind these names has been lost to history. The northwest corner of town in the vicinity of today's Manley and Walnut Streets was known as Jerusalem. The area at the junction of Route 24 and Route 106 is the village of Cochesett, which is a local aboriginal word meaning, "place of the tall pines." South of this village lays Madagascar, which abuts the Scotland area of Bridgewater. To the east of the center lies Westdale, site of the center tree and the geographical center of the ancient town. North of Westdale lies Matfield, which, according to tradition, was named for a Native American who lived along the Salisbury Plain River, as the Matfield River is known by neighboring Brockton.

West Bridgewater as a small town has carried its burden in times of war. Many of the early residents fought in the American Revolution, and more than 130 served in the Civil War, 31 of which died. The town lost 10 of its boys in World War I, seven in World War II, two in Korea, and one in Vietnam. The town's young men and women continue to serve the country with pride and honor, even when it has been unpopular to do so.

The town's major industry has been farming. Among the crops grown in significant numbers in days gone by were apples, pears, blueberries, cranberries, corn, hay, and other feed crops. Today few of these farms survive. The town boasted dairy farms on almost every street, and as the photographs in this volume show, there were many other small family operations. In addition, the town was a center for shoe manufacturing, with firms like Copeland and Hartwell's, founded in 1845, which had as many as 50 employees and a factory in the Jerusalem section of town measuring 130 feet long by 25 feet wide. There was also the Edward Tisdale Shoe Manufactory in Cochesett. Other early town businesses included the M. A Ripley flouring mill; the George W. Bent iron foundry; shoe manufacturers Milvin Edson, Joseph Ring, and T. P. Ripley; and Jonathan Howard, a vinegar manufacturer.

The late 1950s and early 1960s saw a revival in the town as a center of industry. As farms shut down, land became available for companies like Wood-Hu Kitchens, Imperial Millwork, Mammoth Mart Corporation, Component Manufacturing, Turner Steel, and others. Today West Bridgewater seeks to expand its industrial and commercial base to replace many of the businesses no longer a part of the town while at the same time preserving the precious open space once so prevalent in this farming community.

West Bridgewater continues to take great pride in its education system and to keep it relevant to today's changing times. The town can take great pride in students who have gone on to places such as Harvard University, the Massachusetts Institute of Technology, and other great institutions of learning. The town can be proud that the trustees of the Howard Funds manage the bequests left more than 125 years ago by Capt. Benjamin Beal Howard and Otis Drury, which continue to benefit the students of West Bridgewater High School in their post-secondary education.

This small volume cannot and is not intended to be a definitive history of West Bridgewater. Because of its age, so much of the town's history cannot be recalled with visual images, and no great work has recorded the intricacies of daily life in 17th-, 18th-, and 19th-century West Bridgewater. This volume is but a snapshot in time, a collection of images from albums of multigenerational town families and public, private, and institutional collections that have strived to protect some portion of local history. Names, dates, and places remain as they were originally written or given to the author, and apologies are offered for any omissions, deletions, misspellings, or other errors; all such instances are purely unintentional.

One

PEOPLE

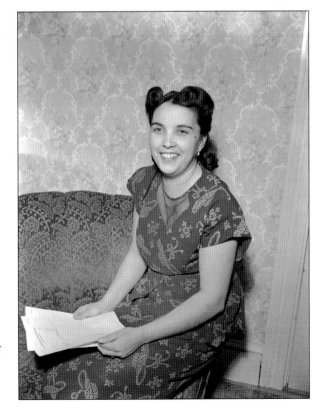

In 1949, Anna Mello Brown became the first woman to serve in the position of town clerk in West Bridgewater. She had worked in the clerk's office under longtime town clerk Herbert Bryant. Giving a lifetime of service to the town, she now serves as the vice president of the Council on Aging. (Courtesy of the Stonehill College Archives and Historical Collections, Stanley A. Bauman Photograph Collection.)

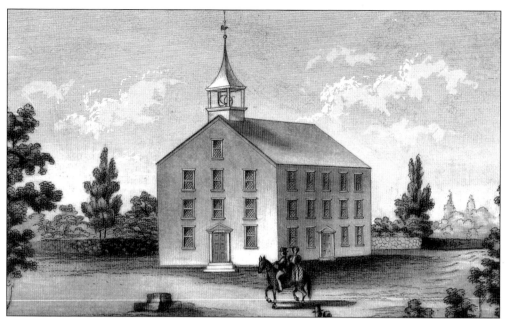

Erected in 1750 where the Civil War monument stands today, the third meetinghouse was a three-story structure with galleries on the interior and served all of old Bridgewater. This structure served as both the religious and political gathering place of the town. In 1801, when the fourth meetinghouse was built on Howard Street, this building was given to the town. (Author's collection.)

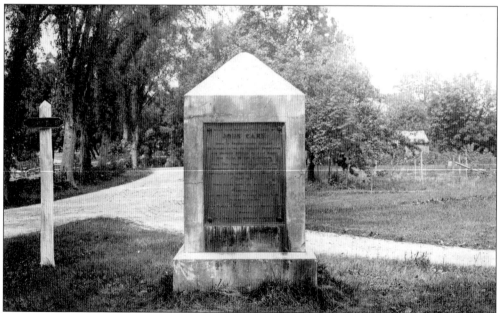

The town's first elected official and one of the original proprietors of old Bridgewater was John Cary (or Carew, as once spelled), who was elected constable in 1656. In 1656, he was also chosen to be the town clerk, a position he held until his death in 1681. This monument erected by his descendants is at the corner of Bryant and South Streets close to where his home stood. (Courtesy of the West Bridgewater Public Library.)

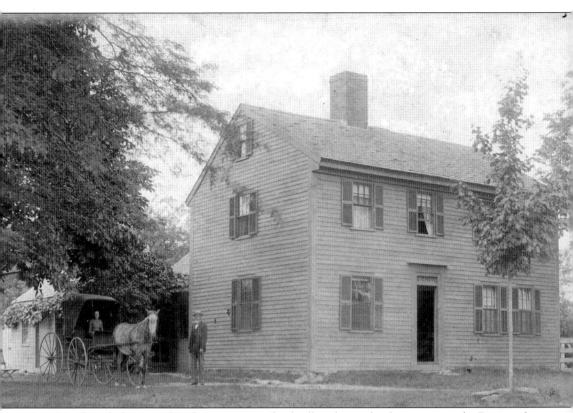

In 1662, the inhabitants of Bridgewater erected a dwelling house for their minister the Reverend James Keith of Scotland. Keith was an 18-year-old student when he was recommended to the town by Rev. Increase Mather. He married Susanna Edson, daughter of Deacon Samuel Edson, and they raised their eight children in this house. The house was originally saltbox style, and in 1678, it was enlarged. From 1676 until 1837, the house remained virtually unchanged. At that time, Thomas Pratt took ownership of the property and removed 14 feet of the rear of the building, giving it the shape seen in this view. Ownership of the property has been limited—Keith and his children owned it until 1722; Ephriam Fobes, his brother, and his son had it until 1792; Amasa Howard and his daughter were owners until 1834; and Thomas Pratt and his descendants owned it until 1949 when Howard Anderson purchased it. The Andersons later deeded the property to the Old Bridgewater Historical Society, and it was restored to its original saltbox shape. (Courtesy of the West Bridgewater Public Library.)

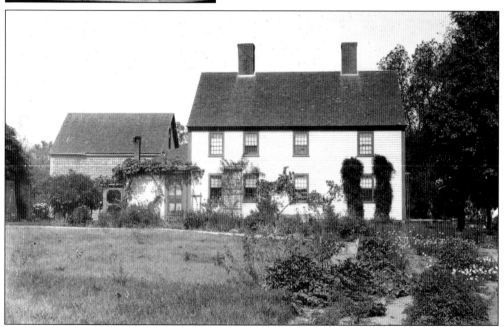

Capt. John Ames was the first of his family to settle in old Bridgewater and was one of the original proprietors of the town. Ames established a shovel works opposite his home on River Street, and it was on this site in 1774 that he forged the first iron shovels manufactured in America. As this image indicates, Ames kept an extensive diary of his life and business activities at West Bridgewater. (Courtesy of Stonehill College.)

This is the Capt. John Ames home on River Street, one of the few remaining double-chimney Colonial homes in West Bridgewater. It is also noted for its symmetrical window arrangement on the east end. It was also the home of Marjorie MacDonald, selectwoman of West Bridgewater, for 18 years. (Courtesy of the West Bridgewater Public Library.)

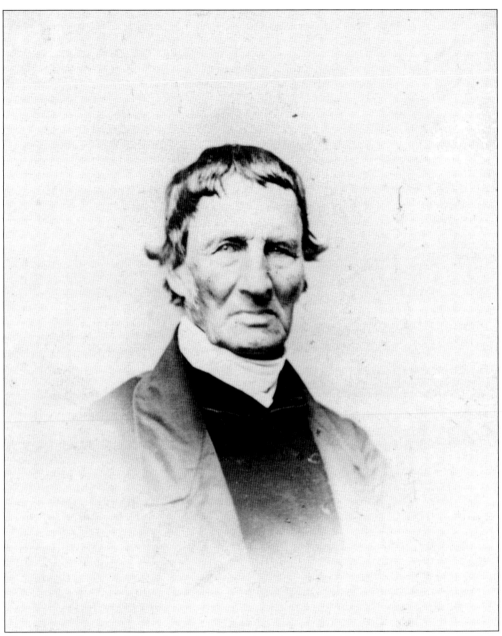

Oliver Ames Sr., son of Capt. John Ames, was born in West Bridgewater on April 11, 1779. In April 1803, he married Susan Angier, daughter of prominent lawyer Oakes Angier. In the same year, Ames moved the main manufacturing operations of the shovel works to North Easton and established the company under the name of Oliver Ames and Sons Shovel Works. He continued to operate ancillary industries at the West Bridgewater site. His two sons, Oliver Jr. and Oakes Ames, grew the company and their careers to great heights. Both were involved in the Union Pacific Railroad, and Oliver Jr. served as governor of Massachusetts. Oakes Ames served as a United States congressman and was a close friend of Abraham Lincoln. Oliver Sr. served in both houses of the Great and General Court of Massachusetts. He died at North Easton on September 11, 1863. (Courtesy of the Easton Historical Society.)

D. & J. Bartlett

W. Billings

N. Leonard

H. Howard

Church

Sale Stable

U. & J. Howard

N. Howard

O. Ship

N. Leonard

S. N. Howard

School

J. Stetson

M. Edson

S. Colwell

Mrs. Tribou

S. Adams

Union School

G. We

E. E. Howard

M. Edson

B. Howard

M. C. Edson

Howard Washburn & Co.

T. Pratt

Mrs. Dunbar

A. Howard

Ho. Washbu

D. Fobe

S. Dunbar

Shoe Shop

Shop

W. Howard

C. E. Howard

M. Ripley

C. Howard

WEST BRIDGEWATER

O. Conle

o 1o 2o 4o 8o

Scale $\frac{1}{2000}$

D. Snow

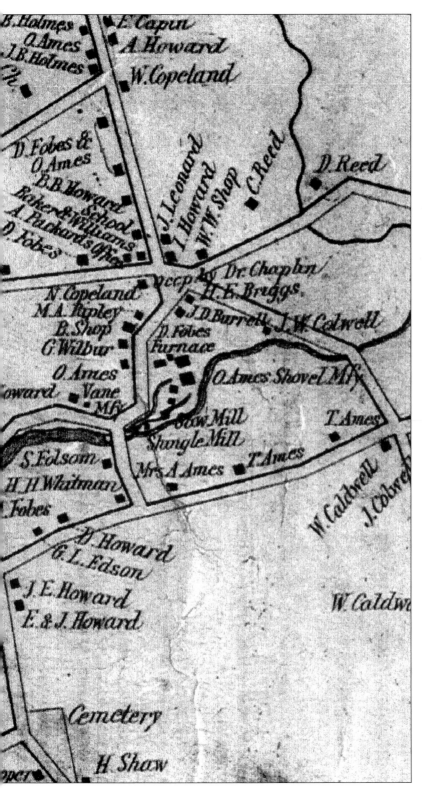

This 1857 map of the center village of West Bridgewater shows the layout and buildings of the Ames complex on River Street. The Ames family was a major presence in this section of town into the 20th century. At the height of operation, their furnaces processed as much as 10,000 tons of bog iron annually, most of it taken from the iron-rich swamps of the region. Located next to John Ames's house was the weather vane shop of J. E. Howard. Today some of his weathervanes have set world-record prices at auctions. Many of the roads and homes shown on this map are still in existence to this day. (Courtesy of the Easton Historical Society.)

Built in 1734, the Ezekiel Reed house is located at 373 Matfield Street. In 1786, it was where Reed, an inventor and manufacturer of fine clocks, made the first machine that could cut and head a nail in a single operation. The descendants of Reed operated rolling mills and other ironworks at Matfield for many years. Reed was also the inventor of the horizontal waterwheel. (Courtesy of Jane H. Taylor.)

Judge Nahum Mitchell, a descendant of Pilgrims, was a 1789 graduate of Harvard College. From 1811 to 1821, he was justice of the circuit court of common pleas. He served in the General Court of Massachusetts and the United States Congress. He was treasurer of Massachusetts from 1822 to 1827, and he was the author of one of the town's classic histories, *Mitchell's History of Bridgewater, Massachusetts*, published in 1840. (Author's collection.)

Capt. Joseph Kingman was born in West Bridgewater on March 14, 1799, on the family farm on Union Street. He attended schools in West Bridgewater and the Hadley Academy. A farmer by birth, Kingman was also a teacher. He was a member of the Constitutional Convention of 1851 and served as a state representative, selectman, and school committeeman. He was also a loyal supporter of William Lloyd Garrison in the argument against slavery. (Courtesy of the Brockton Historical Society.)

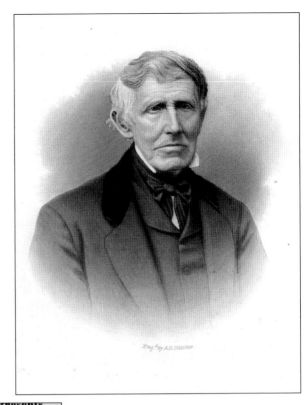

Kingman was a large landowner in the eastern area of town. For the sum of $105, this deed, executed in 1840, sells five acres located in the old cedar swamp in Bridgewater off what is the lower end of Scotland Street today. Kingman's second wife, Elizabeth, signed the deed with him and his neighbor Richard Thayer signed as a witness. (Author's collection.)

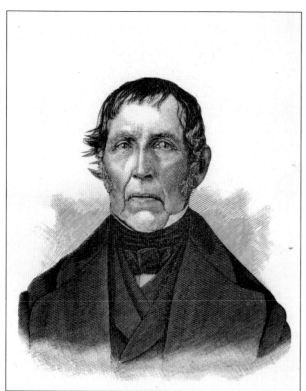

In 1755, James Alger established an iron foundry in the Madagascar section of West Bridgewater. His grandson Cyrus Alger established an ironworks at South Boston in 1809 that by 1850 was the largest in the country. In 1834, Cyrus manufactured the first rifled gun barrel in America. Abiezier Alger, Cyrus's brother pictured here, operated a 100-acre farm and owned the foundry in West Bridgewater, which the family operated well into the 20th century. (Courtesy of the Brockton Historical Society.)

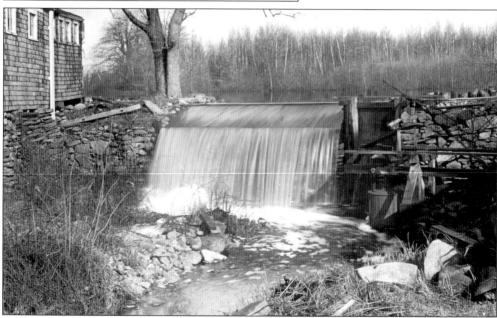

Waterpower was critical to a town's manufacturing and industrial base. In West Bridgewater, manufacturing was concentrated around the center of town. However, on Crescent Street, the dammed-up West Meadow Brook formed a pond that provided water to power a sawmill on the site. The dam, millhouse, and remnants of the manufacturing facility that was on the site remain to this day. (Courtesy of the West Bridgewater Public Library.)

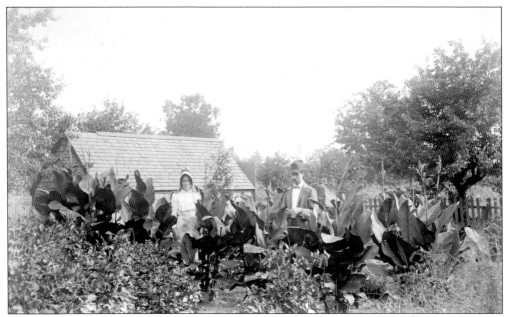

Lost amid the jungle of plants, Joseph and Maude Thayer stand in the garden of their home at 16 Union Street. Joseph took great pride in the maintenance of his home, as did his nephew Erland W. "Ted" Thayer, who later owned the home. Joseph was one of the first residents of town to own a gasoline-powered lawnmower, a reel-style, one-cylinder, crank-start machine. (Courtesy of Duane Thayer.)

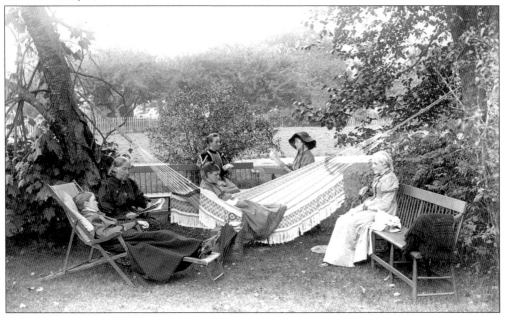

In this genteel image, Clara Wheeler Thayer, seated on the bench to the right, enjoys a quiet summer afternoon among other womenfolk. The woman in the back of the photograph with the hat is reading a copy of *Outlook* magazine. The Thayers were a prominent farming family, and this photograph was most likely taken in Clara's yard at 137 East Street. (Courtesy of Duane Thayer.)

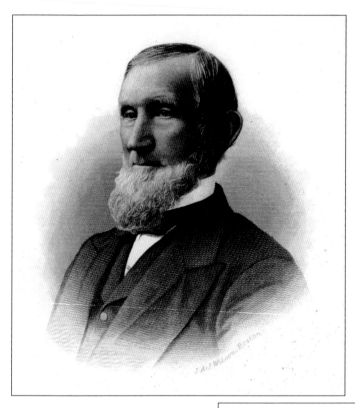

The Copeland family was one of West Bridgewater's preeminent agricultural families. Pardon Copeland was born in West Bridgewater on March 7, 1803, and married Alice White Ames, whose grandfather John had settled in old Bridgewater in 1640. A strong Republican, Pardon never sought but supported those in public office. Capt. Benjamin Beal Howard named him in his will to be a trustee of the Howard Collegiate Institute. (Courtesy of the Brockton Historical Society.)

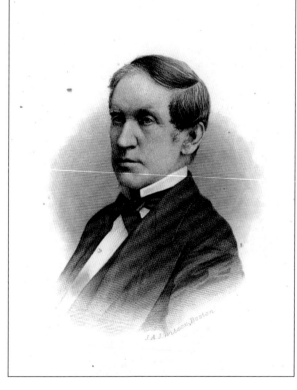

Nathan Copeland, younger brother of Pardon, was born on May 29, 1805. In 1835, when the local shoe industry was in its infancy, he entered into business with his brother, forming the firm of P and N Copeland. This firm was located in the vicinity of where the Brockton Country Club is today. The brothers quickly acquired great wealth and retired in 1879. (Courtesy of the Brockton Historical Society.)

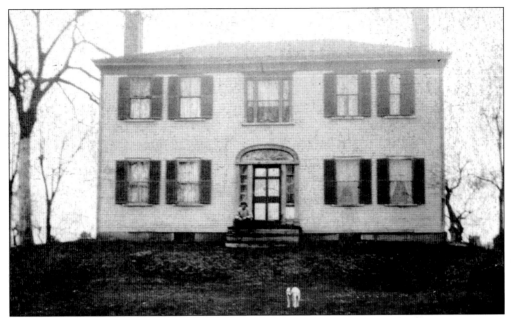

This Federal-style house was built on Cochesett Neck by Salmon Howard in 1815. He married Amelia Snell in 1799, and they raised nine children in this house. Many years later, the house became the home of Samuel Johnson and his family and was located on Maple Street, which, before the construction of Route 24, connected Pleasant and Scotland Streets. (Courtesy of Ethel Rice.)

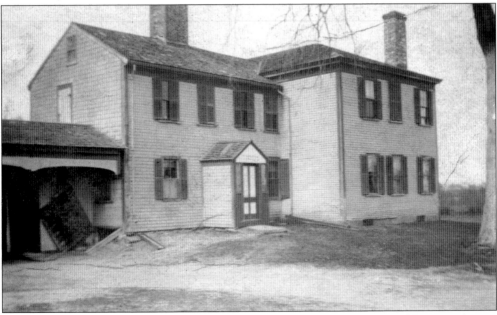

On June 1, 1926, while the Johnson family was asleep, their house was rocked by an explosion, and a major portion of it was destroyed. It is assumed that the intended target of the bombing was Johnson's brother Simon's house on North Elm Street. Simon's wife, Ruth Corinne Johnson, had been a witness at the famous trial of Bartolomeo Vanzetti and Nicola Sacco. No one was injured in the blast. (Courtesy of Ethel Rice.)

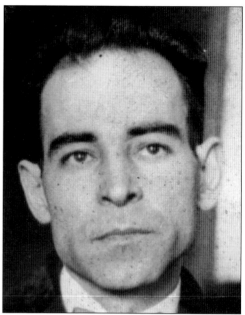

Bartolomeo Vanzetti, left, and Nicola Sacco were anarchists who were tried in the connection of payroll robberies at shoe factories in Bridgewater and Braintree. They had connections with Michael Boda of Bridgewater. Ruth Corinne Johnson identified them as the men who came to pick up Boda's car late at night from her husband, who owned a repair shop in Elm Square. (Courtesy of the Special Collection Department, Harvard Law School Library.)

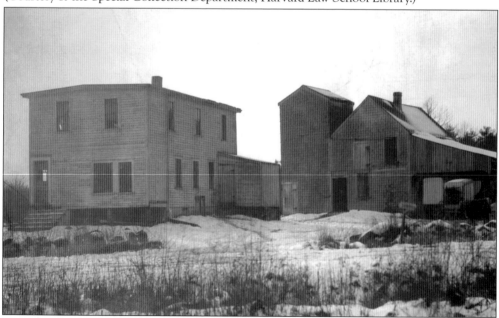

The Armenian house on Lincoln Street was owned by the Ensher family and figured in the trial of Sacco and Vanzetti as a place from which activity could be seen at the Coacci house a little farther down the street. Located in the area of the former Alger Foundry, this section of Cochesett was fairly remote. (Courtesy of the Special Collection Department, Harvard Law School Library.)

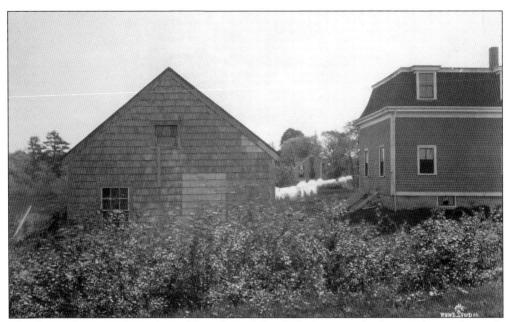

The Coacci house at the corner of Lincoln and South Streets was also known during the trials as the Puffer shack, after the family that owned it. It is reported that one of the cars used by the anarchists was kept in this garage. Boda lived in this house with Ferruccio Coacci, who was also a suspected anarchist. (Courtesy of the Special Collection Department, Harvard Law School Library.)

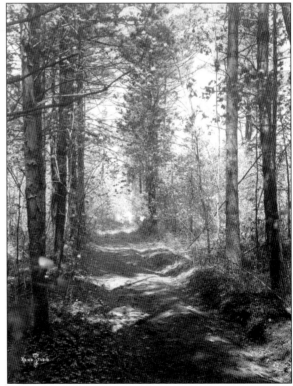

The car that was used as part of the get away in the Braintree robbery where the paymaster was murdered was dumped in a remote section of West Bridgewater known as Manley Woods, named after its owner Albert Manley. This photograph shows the wooded path taken by the car into the woods on the westerly side of Manley Street just north of West Street. (Courtesy of the Special Collection Department, Harvard Law School Library.)

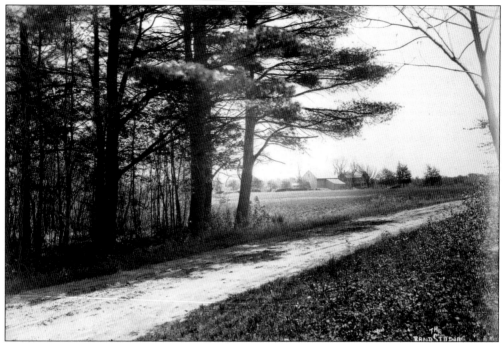

This view was taken from Manley Street, formerly Pine Street, looking toward the town's almshouse and poor farm. This image is from the evidence used in the Sacco and Vanzetti trial to assist jurors in understanding the layout of the town and what took place. (Courtesy of the Special Collection Department, Harvard Law School Library.)

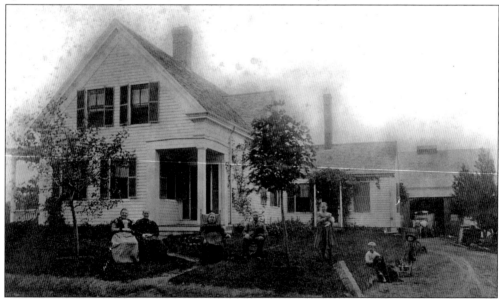

The Kinney homestead was located at 509 North Elm Street. It was the home of Orvis F. Kinney for most of his life and the point from which he operated his wholesale produce farm. Active in town and state government, Kinney was a member of the board of selectmen, served as town auditor, assessor, and water commissioner, and was a member of the Republican town committee. (Courtesy of George Kinney.)

Kinney was perhaps one of the best known and most highly respected citizens in West Bridgewater history. Born in 1880, he was an 1896 graduate of Howard High School and was elected to the Massachusetts House of Representatives in 1909 as one of its youngest members. He was reelected to terms in 1910, 1929, 1930, 1933, 1934, 1935, and 1936. In 1910, he sponsored and obtained passage of a bill that established a town water supply in West Bridgewater. (Courtesy of George Kinney.)

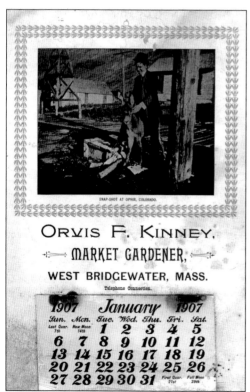

In 1906, Kinney traveled to Colorado and had a photograph of himself taken with a mule, and upon his return, he created this calendar advertising himself as a market gardener. Until his retirement, Kinney ran a successful market garden and wholesale produce business and owned the former store of George Drake in the town center. A staunch Republican, Kinney was also a 50-year trustee of the Howard Seminary. (Courtesy of George Kinney.)

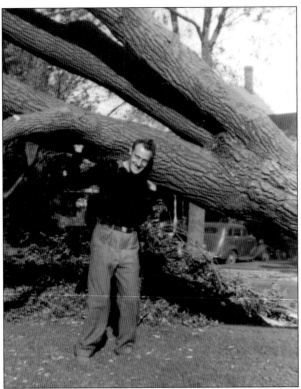

The Hurricane of 1938 devastated much of New England, and West Bridgewater was not immune. In this photograph, Clifford Broman appears to be almost Herculean in standing with a fallen giant on his shoulders. This tree in front of the family home on North Elm Street was one of hundreds of victims of the storm. Broman also served in the Marine Corps in World War II. (Courtesy of Forrest Broman.)

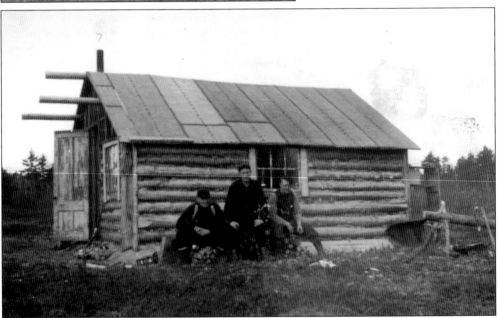

A long way from West Bridgewater, three town residents, Albert Howard, Algot Benson, and John Hayward, enjoy the rustic bare-bones simplicity of a hunting cabin in the Cherryfield area of Maine. Howard and Hayward were both well-known farmers with family lineage tracing back to the town's founding. Benson, a Swedish immigrant, was a self-employed mason and served as a foreman on the War Memorial Park project. (Author's collection.)

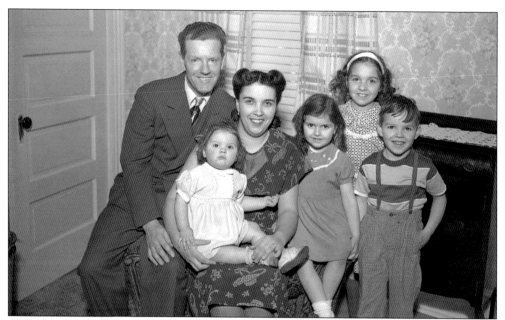

William and Anna Mello Brown, shown here in 1949 with their children, from left to right, Kathryn, Judith, Patricia, and William, had the distinctive honor of being the first couple to be married in St. Ann's Church. The wedding took place on Memorial Day, May 30, 1938, with Fr. Cornelius Reardon officiating. (Courtesy of the Stonehill College Archives and Historical Collections, Stanley A. Bauman Photograph Collection.)

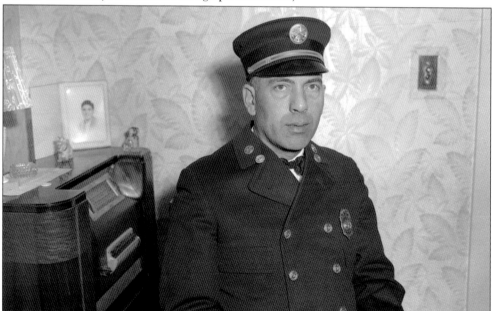

On March 23, 1949, the board of selectmen appointed acting fire chief Antone Sousa as the permanent chief to replace Edward L. Bourne, who had been off the job and resigned due to ill health. Two days before his appointment, on March 21, Howard High School was destroyed in a massive fire. (Courtesy of the Stonehill College Archives and Historical Collections, Stanley A. Bauman Photograph Collection.)

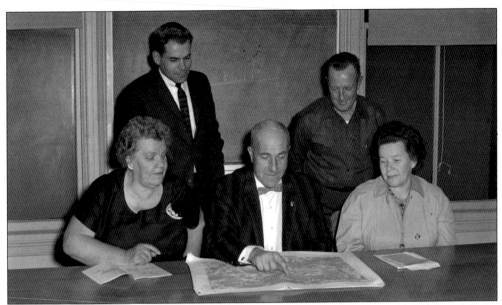

Members of the 1965 conservation commission meet with Richard Chamberlain of the Bridgewater Conservation Commission to discuss water pollution. From left to right are (first row) Walborg A. Johnson, Thomas B. MacQuinn, and Jessie Anderson; (second row) Richard K. Chamberlain and J. Layton Hayward. Johnson, Anderson, and Hayward were all farm owners in town. (Courtesy of the Stonehill College Archives and Historical Collections, Stanley A. Bauman Photograph Collection.)

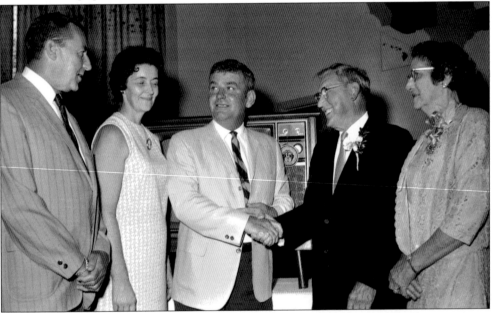

In September 1969, Arvid Hagglund was honored at a retirement party recognizing his 33 years as a custodian in the school system. From left to right are DeSales J. Heath, school committee chairman; Shirley Hoyt and Carl R. Ohlson, event cochairpersons; and Hagglund and his wife. (Courtesy of the Stonehill College Archives and Historical Collections, Stanley A. Bauman Photograph Collection.)

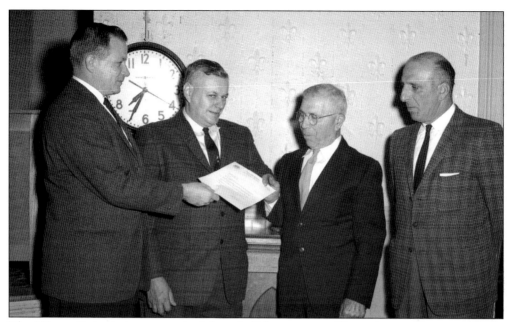

The Water Commission recognized Joseph Falzarano, age 75, on his retirement in 1962. Pictured from left to right are John W. Noyes, water commissioner; William E. Nickerson, water superintendent; Falzarano; and Edward G. Asack, water commission chairman. (Courtesy of the Stonehill College Archives and Historical Collections, Stanley A. Bauman Photograph Collection.)

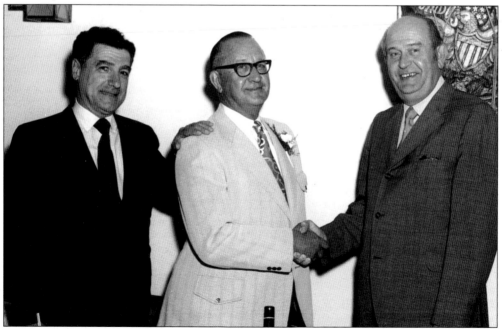

Selectman George V. Hollertz Jr., center, is congratulated by selectmen Michael Manugian, left, and Richard E. Krugger. Hollertz, first elected a selectman in 1960, chose not to run for a fifth term and retired in 1972. He served as a member of the town's industrial development committee and finance committee for many years as well. (Author's collection.)

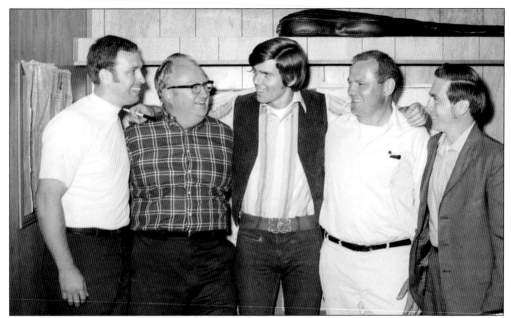

Broadway star John Hamilton Davidson visits with former classmates and friends in July 1969. From left to right are Ronald B. Newman, James A. Ross, Davidson, Richard A. Chisholm, and Richard A. Anderson. Davidson lived at 294 East Street with his parents and brothers while his father served as pastor at the First Baptist Church in Brockton. (Courtesy of the Stonehill College Archives and Historical Collections, Stanley A. Bauman Photograph Collection.)

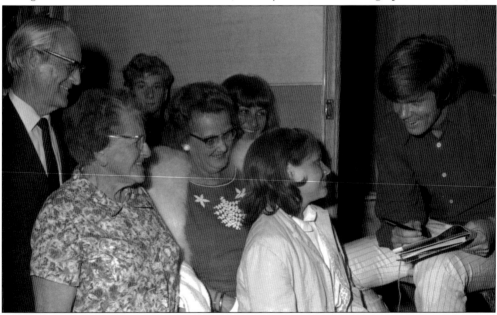

On July 10, 1969, Davidson, while at the Brockton Fair, greets his parents, former neighbor Marjorie Chisholm, and her granddaughter Christina Chisholm. In the photograph from left to right are Rev. Dr. James Davidson, Marjorie, Elizabeth Davidson, and Christina. (Courtesy of the Stonehill College Archives and Historical Collections, Stanley A. Bauman Photograph Collection.)

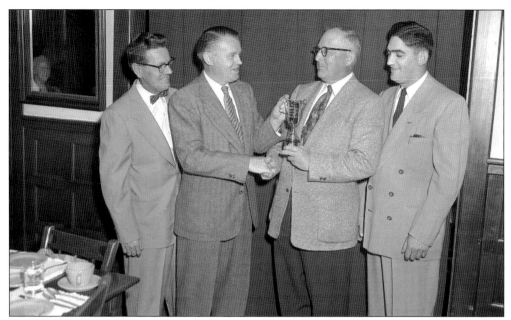

The West Bridgewater Lions Club was recognized as outstanding among the 22 in its district in 1954. Receiving the award on behalf of the club from left to right are William R. Brown, district governor; Joseph Kaspar, king lion; Harvey A. Scranton; and king lion–elect Julian E. Lucini. (Courtesy of the Stonehill College Archives and Historical Collections, Stanley A. Bauman Photograph Collection.)

Sharing a moment at the piano with her young neighbors, Effie Hayward is joined, from left to right, by Allen P. Hoyt, Ernestine Holmgren, and Scott D. Holmgren. Hayward had a career in church music spanning 65 years, 52 of them as organist at the Gammons Memorial Church in Bridgewater. (Courtesy of the Stonehill College Archives and Historical Collections, Stanley A. Bauman Photograph Collection.)

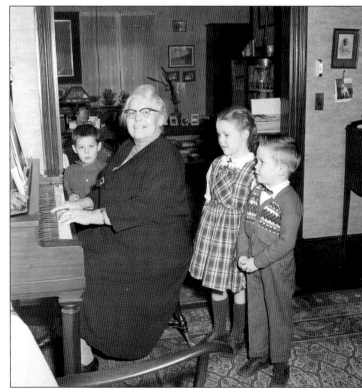

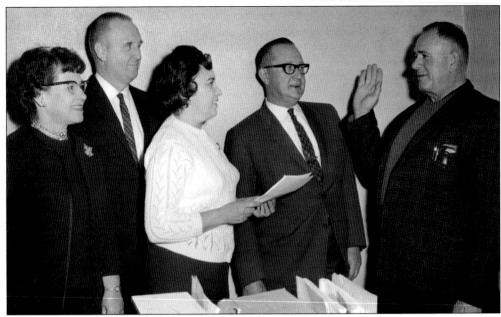

In 1966, Edwin T. Gibson, right, was sworn in as fire chief by town clerk Anna Brown, center. Observing the moment from left to right are selectmen Marjorie MacDonald, Merton Ouderkirk, and George V. Hollertz. Gibson served for many years on the police department as well, having achieved the rank of lieutenant. (Courtesy of the Stonehill College Archives and Historical Collections, Stanley A. Bauman Photograph Collection.)

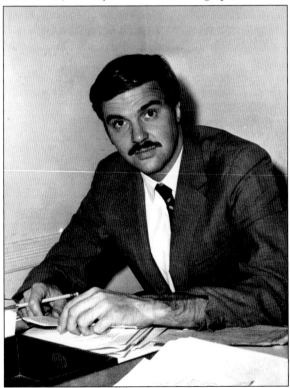

President of the 1957 class of West Bridgewater High School, Forrest Broman graduated Phi Beta Kappa from Brown University, where he captained the Brown basketball team and won all-ivy recognition in 1961. A cum laude graduate of Harvard Law School, Broman served as an aide to Mayor John Lindsay of New York City. From 1973 to 1996, he directed schools in Israel and Venezuela. He now publishes the *International Educator*, a newspaper serving schools worldwide. (Courtesy of Forrest Broman.)

Graduating from West Bridgewater High School in 1963, James (Jim) Cheyunski went on to Syracuse University and in 1968 was drafted by the then Boston Patriots football team where he remained until 1973. He then joined the Buffalo Bills and ended his nine-year professional career with the Baltimore Colts. (Courtesy of the Stonehill College Archives and Historical Collections, Stanley A. Bauman Photograph Collection.)

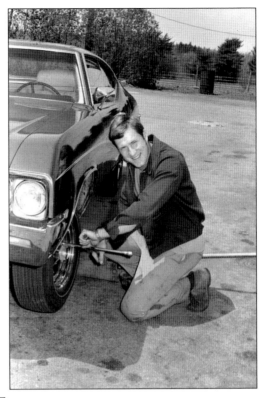

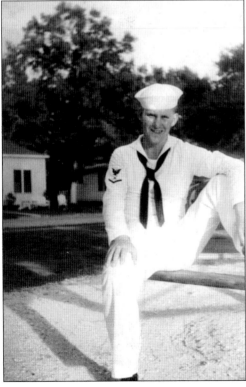

Robert Ernest Lindgren, like so many others of the time, went directly from high school into the military. Graduating from Howard High School in 1944, Lindgren joined the navy in September of that year and became a 3rd class gunner's mate. After the service, Lindgren worked as a master carpenter for the T. F. Crowell Company of Brockton for more than 30 years. (Courtesy of Robert E. Lindgren.)

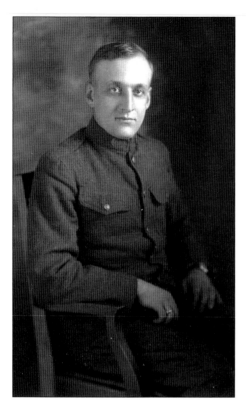

As with many young men of his era, Forrest Ohlson of North Elm Street went off to fight in "the war to end all wars." Ohlson was one of the 1.3 million troops that fought at the battle of the Argonne Forest in World War I. In this battle, which lasted from September 26 until November 10, 1918, he was gassed and suffered the remainder of his life from the effects of the attack. The Argonne is considered to be the bloodiest battle in U.S. military history. Ohlson died in 1951. (Courtesy of Forrest Broman.)

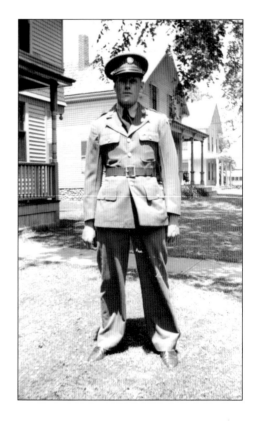

Pictured here in 1942 is Julian S. Hughes, owner of Richard's Corner Store at 4 Plain Street. Hughes served in the U.S. Army during World War II. He was in the 101st Infantry, 26th Division, Company C. Shortly after the war, Hughes bought into the store with partner Robert Larkin of Larkin's Leather in Brockton. (Courtesy of the Julian S. Hughes collection.)

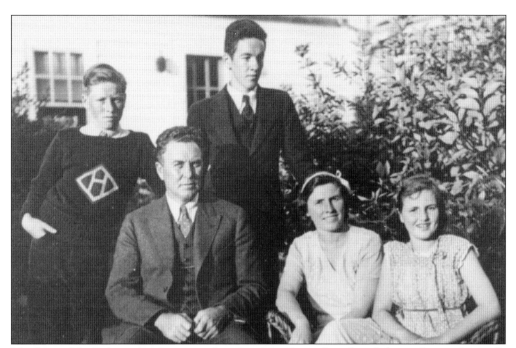

Members of the Roberts family, pictured on their East Street farm from left to right, are Stuart, E. Marion, Walter, Jean, and Alice. Stuart, a lieutenant in the naval reserve died a hero's death on Guam in 1944 during World War II protecting Task Force 58 from Japanese fire. E. Marion was an athletic director and football coach at Brockton High School for 37 years, being undefeated in 1924, 1932, and 1945. (Courtesy of Jonathan Roberts.)

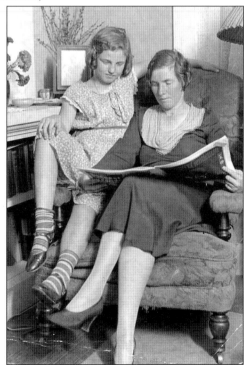

Jean Roberts is with her mother, Alice Orr Roberts, in the family home on East Street. The Roberts family operated a large farm, growing corn, other vegetables, and apples. The farm was later owned and operated by Fred Bisbee and Frank "Sonny" Parker and is today operated by members of the Parker family. (Author's collection.)

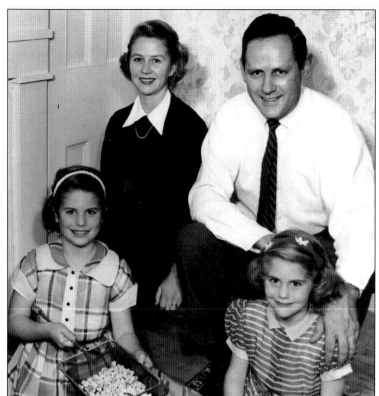

Hastings Keith and his wife, Louise, pose with their daughters Helen, left, and Carolyn in their home on River Street. Hastings was the son of Roger Keith Sr., a former mayor of Brockton. He was also a partner in the Roger Keith and Sons Insurance Agency with his father and brother Roger Keith Jr. After the death of his brother, Hastings was joined in the firm by Scovel Carlson and Robert Meadows. (Courtesy of Carolyn Keith Silvia.)

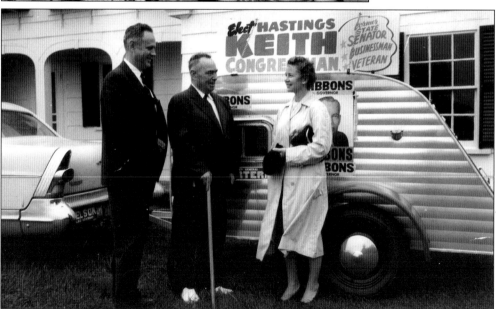

Serving as a state senator from 1953 to 1956, Hastings ran unsuccessfully for congress in 1956. In 1958, he was elected to the United States House of Representatives, where he served from January 3, 1959, until January 3, 1973. On the campaign trail, "Hasty," as he was known to his friends, is pictured here on the left with his wife, Louise, and Speaker of the House Joseph Martin. (Courtesy of Carolyn Keith Silvia.)

Thomas P. "Tip" O'Neill, left, is pictured here at the United States Capitol with Hastings. Both insurance men served together in Congress, representing Massachusetts. Hastings, a conservative Republican, worked vigorously to protect the state's fishing and agricultural interests. He was a strong backer of the Cape Cod National Seashore and was instrumental in filing legislation that made it a reality. (Courtesy of Carolyn Keith Silvia.)

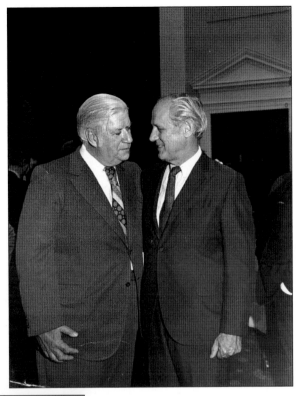

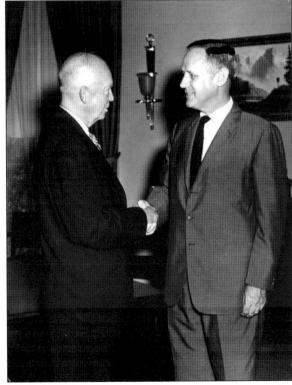

Hastings shakes hands with Pres. Dwight D. Eisenhower. Hastings, a 1938 graduate of the University of Vermont, served in the army during World War II, spending 18 months overseas in Europe and serving on General Eisenhower's staff. After the war, he became a colonel in the army reserve. He died in his native Brockton on July 19, 2005, at the age of 89. (Courtesy of Carolyn Keith Silvia.)

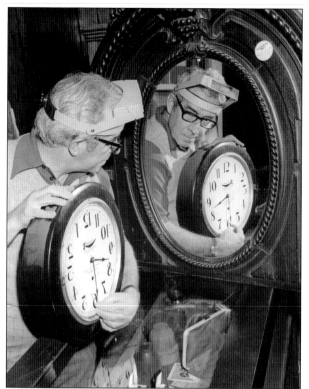

In this unusual photograph, Luke M. Boyd of 11 High Street looks into a mirror at the face of a clock he is repairing. This image was taken by Stanley A. Bauman to promote the changing of the clocks to daylight savings time. Boyd was a talented and expert clock repairman, working on all sizes and ages of clocks and watches. (Courtesy of Karolyn Boyd.)

In 1958, the Howard Seminary, also known as the Howard School for Girls, expanded with the building of a new facility, known today as the Howard Elementary School building. Pictured from left to right at the May 10 groundbreaking are Maj. Leo Graham, Orvis Kinney, John Partridge, Rev. Norman MacLeod, Vida Clough (director of the Howard Seminary), and Rev. Everett Washburn. (Courtesy of the Stonehill College Archives and Historical Collections, Stanley A. Bauman Photograph Collection.)

Two

EDUCATION

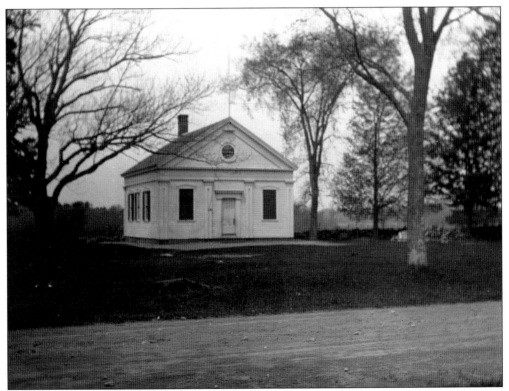

From the Colonial days when Bridgewater's John Cary was the first teacher of Latin in Plymouth Colony, education was important to the local citizens. In the days before transportation was provided to students, each section of the town had its own schoolhouse. At one time, there were as many as eight. Pictured here is the Center Primary School, which was located on West Center Street near Howard. (Courtesy of Jac MacDonald.)

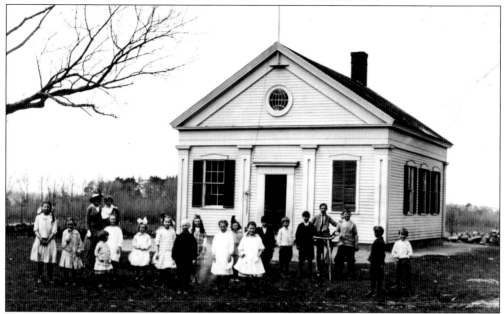

The Center Primary School was located just west of the present high school and was similar in design to the other schools in town at the time. These schoolhouses were located on South Main Street, East Street, Matfield Street, North Elm Street, and in Cochesett and Jerusalem. At one time, the school for the central district was located across from present-day St. Anne's Church. (Courtesy of the West Bridgewater Public Library.)

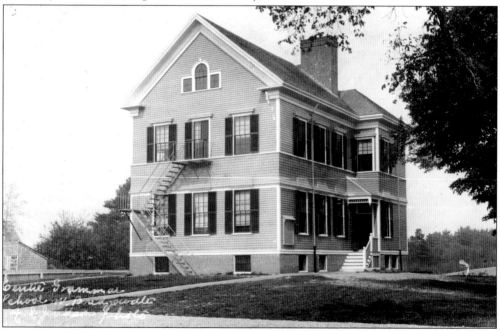

For nearly a half century, the Center Grammar School was under the care of Rose L. MacDonald. Hired in 1890, MacDonald retired in 1939 after 49 years of service to the town. Admired, loved, and respected by three generations of students, the Rose L. MacDonald School off North Elm Street was named in her honor. (Courtesy of the West Bridgewater Public Library.)

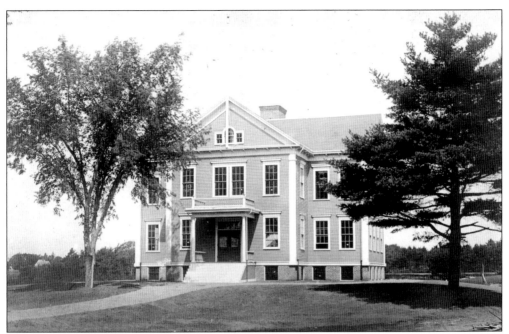

The new Center School was built in 1908 on West Center Street adjacent to the Center Grammar and Center Primary Schools. These buildings were located where the west end of the current middle/senior high school is located. This two-and-a-half-story wood-frame structure was built at a cost of $13,500. (Author's collection.)

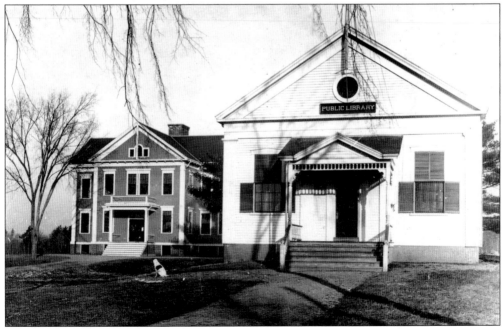

The Center Primary School, pictured in the foreground, became the home of the West Bridgewater Public Library in October 1908. The library, founded in 1879, was first housed in the post office building in Monument (Central) Square and in 1881 was moved into more spacious quarters in the Howard School. (Courtesy of the West Bridgewater Public Library.)

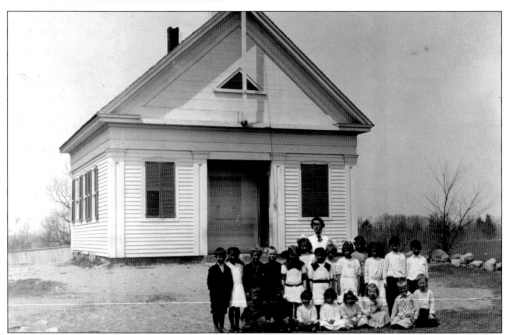

The North School, as pictured here, was built in 1906 upon lots eight and nine on North Elm Street. These lots were purchased from a Reverend Moulton for $475. The land committee consisted of Clinton P. Howard, L. Augustus Tower, and William E. Fay. This schoolhouse replaced an earlier building in the region. (Courtesy of the West Bridgewater Public Library.)

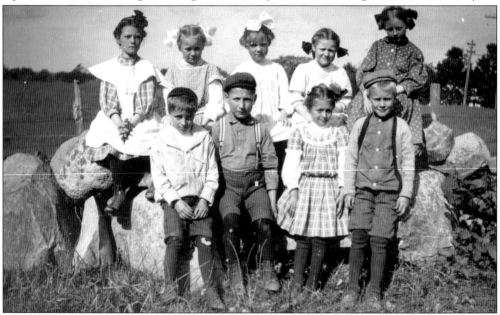

This photograph from 1907 or 1908 shows students from the area outside the North School. From left to right are (first row) Edmund Ferranti, Edmund Silva, Marion Pike, and Herbert Carlson; (second row) Myrtle Corbett, Blanche Young, Doris Horton, Eleanor Worthington, and Hazel C. Snow. In 1925, the North School was consolidated into the Sunset Avenue School, which was built in 1911. (Courtesy of the West Bridgewater Public Library.)

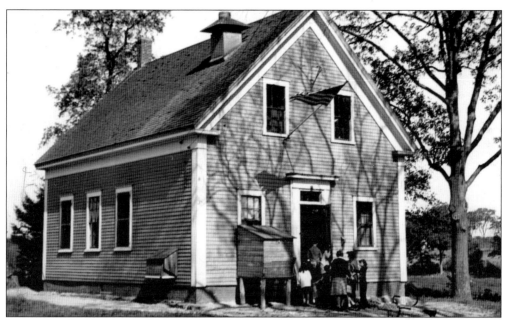

Located on Walnut Street, the Jerusalem School was by far the most remote of the town's schools. Built in 1866, it was electrified in 1925, and in 1948, a back door was added, eliminating the need for the children to jump out the windows during a fire drill. Adelbert Goss, who lived next door, sold candy out of his kitchen to children on their way to school. The Jerusalem School was closed in 1952. (Courtesy of Leah Soell Benson.)

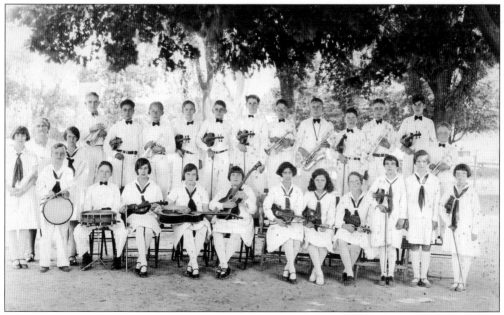

Music was an important part of the school curriculum in the 1920s, as is indicated by the large number of children and variety of instruments in this photograph of the Center School orchestra. Principal Rose L. MacDonald is seen in the left of the photograph. In the back row, third from left is George V. Hollertz, a future town selectman. Seventh from the left is future school committee member Stanley O. Carlson. (Author's collection.)

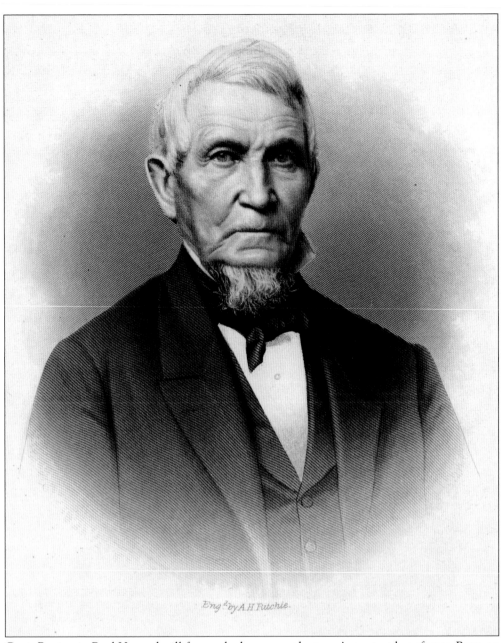

Engᵈ by A.H. Ritchie.

Capt. Benjamin Beal Howard will forever be known as the town's greatest benefactor. Born on March 2, 1788, Howard was educated in the town's schools and was the fifth generation of his family to own and occupy their ancestral home and tavern at the corner of River and Howard Streets. About 1837, he moved to New Bedford and became active in the whaling industry while still maintaining his home and voting rights in West Bridgewater. He died in New Bedford on April 3, 1867. Upon his death, Howard left the sum of $80,000 to West Bridgewater, the interest of which was to be used for "the establishment of a high school . . . to be called the Howard School." Howard High School was built with these funds, and to this day, local students continue to benefit with scholarships from this 142-year-old bequest. (Courtesy of the Brockton Historical Society.)

Howard made much of his fortune in the whaling industry. He was a partner in the ownership of various vessels, as this document indicates. He owned ships, including the *Inez*, a 356-ton vessel, the *Parachute*, and the *Henry Kneeland*, a 304-ton vessel that was lost in Arctic ice in July 1864. (Courtesy of Mystic Seaport, Charles W. Morgan Collection.)

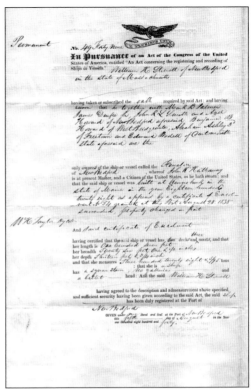

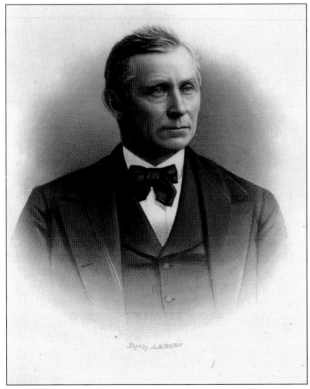

Francis Edward Howard, the son of Capt. Benjamin Beal Howard, was born in West Bridgewater on May 14, 1825. Formerly a Whig, in 1854 Francis Edward Howard became the first town resident to declare himself a Republican as that party was being formed. Founder of the town's public library, he was also a selectman, member of the school committee, and member of the state legislature. (Courtesy of the Brockton Historical Society.)

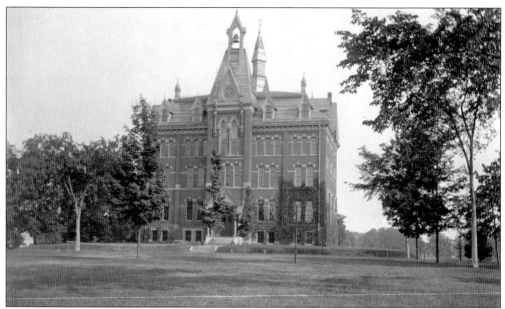

The Howard Collegiate Institute, seen here from Howard Street, opened on October 2, 1883, as a school for young women. The building also housed the town's public high school, Howard High School. In addition, the building was the first home of the West Bridgewater Public Library. The bell in the north tower was the gift of Otis Drury, who died on the day the school formally opened. (Courtesy of Jac MacDonald.)

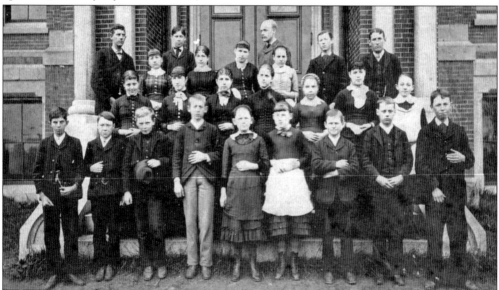

In 1882, Howard High School students pose on the building's steps. Listed in no particular order are Frank E. Alger, Walter L. Barrel, Willie J. Howard, Julie A. Wheeler, Ada W. Leach, Mabel N. Copeland, Jennie B. Packard, George W. Alger, Lizzie F. Hewins, Alice R. Bartlett, Clara B. Leach, Lida W. Copeland, Lottie A. Logue, Nellie C. Cashion, Alice M. McAdams, Arthur D. Copeland, Clarence S. Atwell, Herbert S. Packard, Fred W. Kingman, Bertha C. Leonard, Annie K. Barrel, Oscar B. Leonard, Charles E. Lothrop, Frank W. O'Connor, and teacher Ralph Barker. (Courtesy of the West Bridgewater Public Library.)

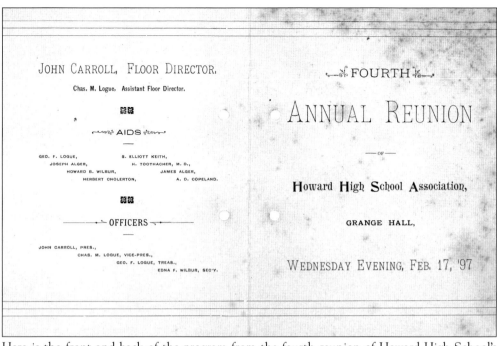

Here is the front and back of the program from the fourth reunion of Howard High School's class of 1883, the school's first graduating class. The reunion was held on February 17, 1897, in the Grange hall, which is the town hall today. One of the aids for the evening was Howard G. Wilbur, who later served as town moderator for 40 years. (Author's collection.)

This is the inside of the reunion program shown above, displaying the evening's concert and dance programs. Fourteen dances are listed on the card with music being provided by Porter's Orchestra, the Apollo Quartette of Boston, and others. (Author's collection.)

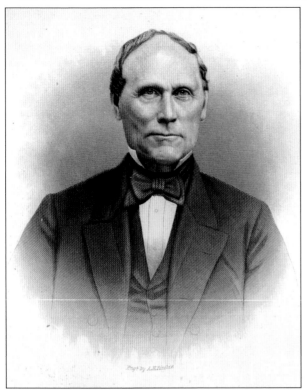

Otis Drury was a native of Natick and began his career as a teacher before becoming a businessman. On October 6, 1836, he married Julia A. Alger of West Bridgewater and made West Bridgewater his summer residence and then his permanent home later in life. Drury was a strong supporter of the First Congregational Church and a generous benefactor to all religious institutions. (Courtesy of the Brockton Historical Society.)

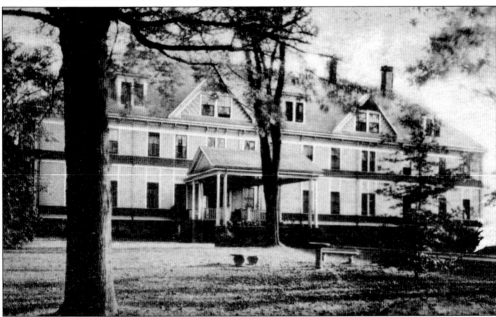

One of the original trustees of the Howard Funds, named as such in the will of Capt. Benjamin Beal Howard, Drury was a generous benefactor of Howard High School in his own right. The commodious wood-frame classroom building and later dormitory with its mansionlike interior elements was named in honor of Drury and his wife and stood near where the public library is today. (Author's collection.)

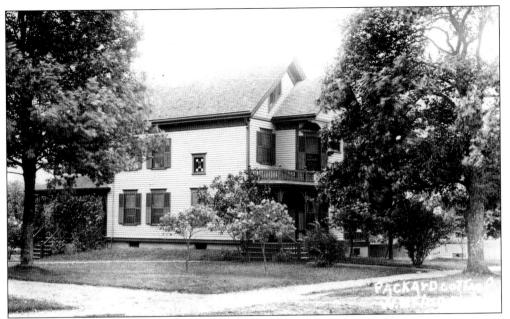

Packard Cottage was once the home of Charles Packard, who served the town as postmaster and town clerk. This classic Victorian home was adjacent to the Howard School property and was eventually acquired through bequest by the trustees of the Howard Funds. This property was demolished in the 1960s along with Drury Hall. (Courtesy of the West Bridgewater Public Library.)

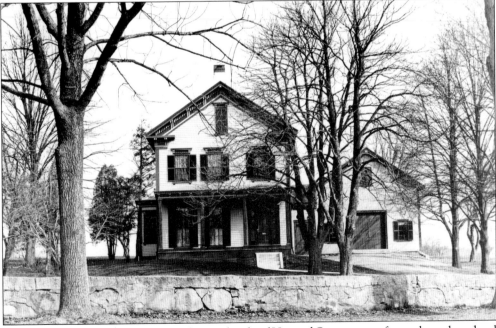

The chancellor's house, located on the north side of Howard Street across from where the school stood, was home to the school's director. This house played host to various gatherings of trustees and school benefactors. The house and setting look very much the same except that the barn is no longer in existence. (Courtesy of the West Bridgewater Public Library.)

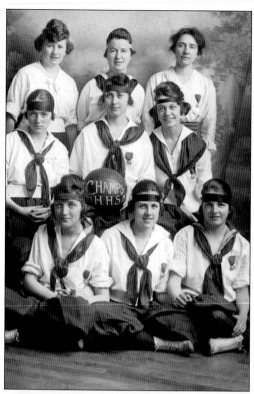

Neatly attired and posing for a championship photograph, the 1919 Howard High School girls' championship basketball team from left to right includes (first row) Margaret Kent, Evelyn Andrews, and Phyllis Logue; (second row) Adele Holbrook, Margaret O'Neil, and Frances Johnson; (third row) Blanche Young, Bernice Belmore, and coach Lillian Turner. (Courtesy of the West Bridgewater Public Library.)

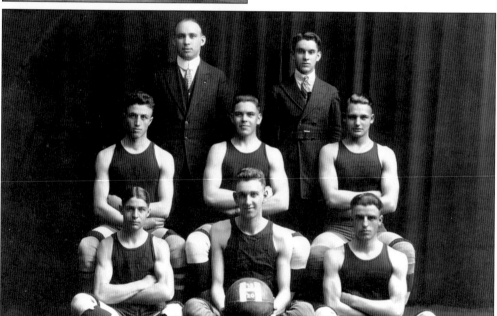

With a record of 22 wins and no losses, the 1919–1920 boys' basketball team of Howard High School appears proud of their accomplishment in this team photograph. From left to right are (first row) Noble Lapworth, John Barker, and Edmund Ferranti; (second row) Frank Ferranti, Eldon Hambly, and Carroll Pike; (third row) coach H. V. Lawson and manager Paul MacDonald. (Courtesy of Claire Hambly Black.)

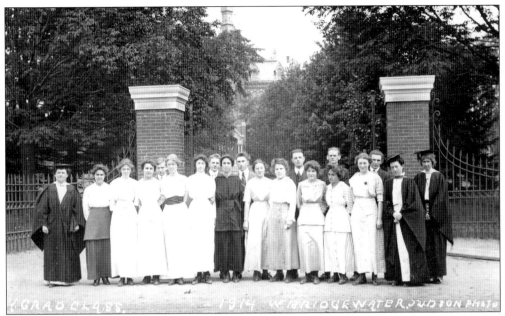

Gathering in front of the entrance to Howard High School, the class of 1914 includes Mary Blair Lasey, Elizabeth Welch, Gladys Hunt, Lottie Cheney, Isaac Howard, Gertrude Wilbur, Catherine O'Neil, Ralph Langley, Mary Luddy, Lawrence Fallon, Katherine Parry, Henry Wheeler, Elwyn Baker, Gladys Brown, Salome Alger, John Cairns, Bertha Lawrence, and Marion Munsey. (Courtesy of the West Bridgewater Public Library.)

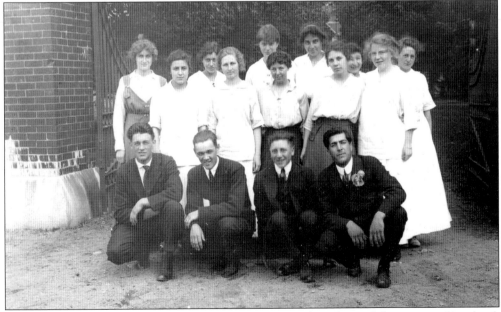

Howard High School's class of 1916 poses for a photograph in front of the gates to the school. From left to right are (first row) Willard Peterson, Earl Lothrop, Warren Denley, and Edward Ensher; (second row) Helen Palmer, Nellie Ferrenti, Eva Dolbeck, Winifred Campbell, Deborah Brooks, Doris Brown, Gladys Cogswell, Ethel Andrews, unidentified, Eunice Logue, and Irene Wilbur. (Courtesy of the West Bridgewater Public Library.)

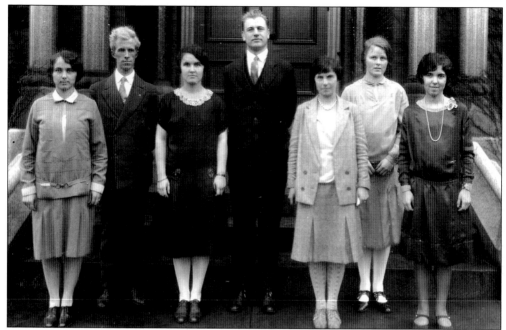

The small Howard High School faculty gathered on the steps of the school for this 1931 photograph. Pictured second from left is Arthur Frellick, and fourth from left is Nils Lindell, who had the distinction of being the longest-serving principal in the school's history until his record was surpassed by S. Erick Benson. (Courtesy of Richard and Helen Cogswell.)

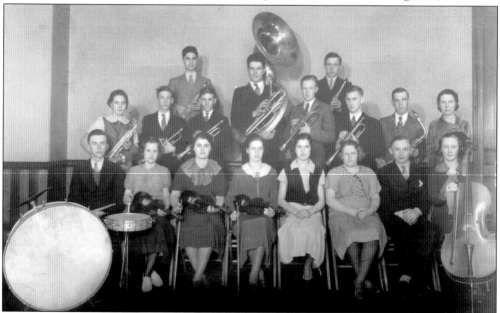

This view of the 1934–1936 Howard High School orchestra, from left to right, shows (first row) Warren Gardner, Agnes Hackenson, Helen Falzarano, Irma Crossman, Claire Moss, Ellen Fisk, Elmer Harlow, and Ruth Tuck; (second row) Florence Hayden, Charles Rubin, Gene Fongeallez, John Gonsalves, Myrl Hurley, Layton Hayward, Bruce Edson, Sherman Mosher, LaForest Wibur, and unidentified. (Courtesy of Richard and Helen Cogswell.)

At 10:10 a.m. on March 21, 1949, fire was discovered on the upper floor of Howard High School by custodian Arvid Hagglund. With the fire spreading quickly, the roof collapsed at 11:00 a.m., and at 11:20 a.m., the bell tower collapsed. Water pressure was so low that firemen were throwing snowballs at the windows to break them. (Courtesy of the Stonehill College Archives and Historical Collections, Stanley A. Bauman Photograph Collection.)

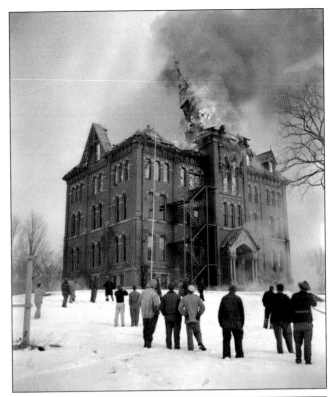

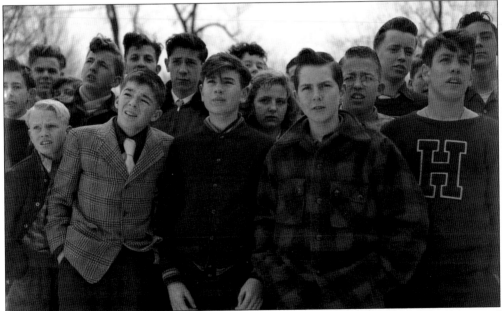

More than 250 students and faculty safely evacuated the building under the direction of principal Richard Grodin. These students gathered on the snow-covered lawn of the school to watch its demise. The school, with all its contents, was a total loss. Pictured second from the right in the back row is Howard R. Anderson, the town's future chief of police. (Courtesy of the Stonehill College Archives and Historical Collections, Stanley A. Bauman Photograph Collection.)

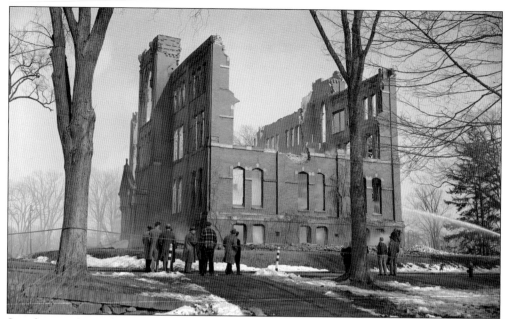

Standing eerily in the stark spring sky are the remains of Howard High School. Students were accommodated in the afternoon with classes being held in Bridgewater from 1:45 p.m. until 6:00 p.m. Chemistry classes were held at Brockton High School on Saturdays. The sports teams practiced in the morning hours before school. (Courtesy of the Stonehill College Archives and Historical Collections, Stanley A. Bauman Photograph Collection.)

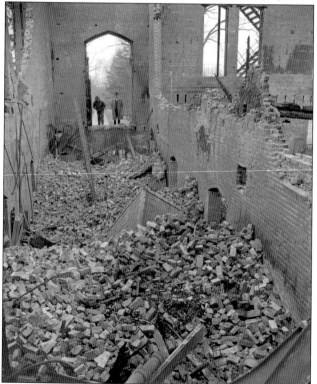

Framed by the building's massive door opening, officials stare into the brick and rubble-filled basement where a safe seems to rise above the debris. By 12:30 p.m., a little more than two hours after the fire was discovered, all that remained of the massive structure were its north and south walls and half the west wall. (Courtesy of the Stonehill College Archives and Historical Collections, Stanley A. Bauman Photograph Collection.)

The school's grand entrance with its polished marble columns and ornate frieze frames the devastation of the conflagration. Constructed of brick and stone, the building's wood interior and other flammable materials, which, combined with open staircases winding up through the structure, made stopping the fire next to impossible. (Photograph by Paul Slater, author's collection.)

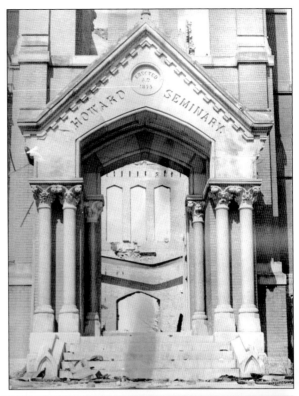

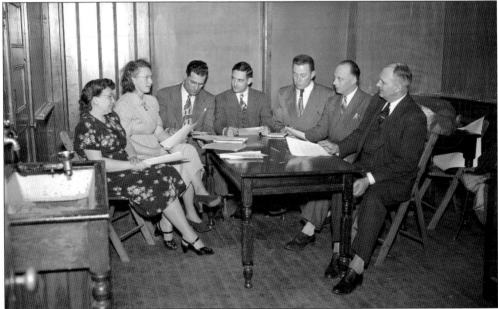

Meeting in the aftermath of the devastating fire, the school committee discusses ways to continue classes for 265 students. From left to right are Dorothy F. Alexander, Ruth M. Caswell, Adrian A. Beaulieu, superintendent of schools William H. Rodgers, Thomas F. Kemp, Erland W. Thayer, and A. Russell Mack from the state department of education. (Courtesy of the Stonehill College Archives and Historical Collections, Stanley A. Bauman Photograph Collection.)

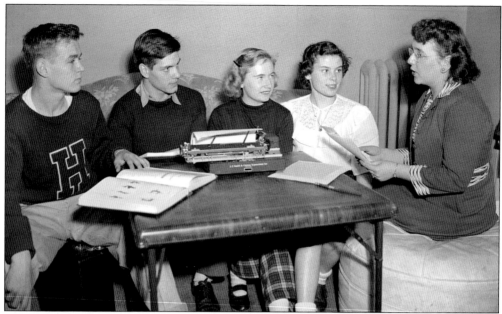

After the fire that destroyed their school, the students organized a benefit dance to raise funds to replace equipment. Meeting in March 1949 at the home of principal Richard Grodin, from left to right are William R. May, Earl E. Carr, Beverly M. Spillane, Patricia L. Leighton, and faculty advisor Evelyn H. Viens. (Courtesy of the Stonehill College Archives and Historical Collections, Stanley A. Bauman Photograph Collection.)

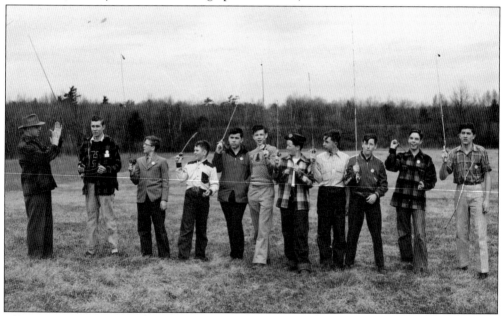

The 1950 Rod and Reel Club of Howard High School was thought to be the only such club in Massachusetts at the time. Members from left to right are former Maine guide and advisor Winthrop Jackson, S. Erick Benson, Frank T. MacLeod, Ronald E. Allen, Lawrence G. Lyons, Donald H. Foye, Arvin I. Philippart, Robert J. Young, Robert A. Cochran, Henry H. Hurley, and Clyde D. Jopling. (Photograph by Stanley A. Bauman, author's collection.)

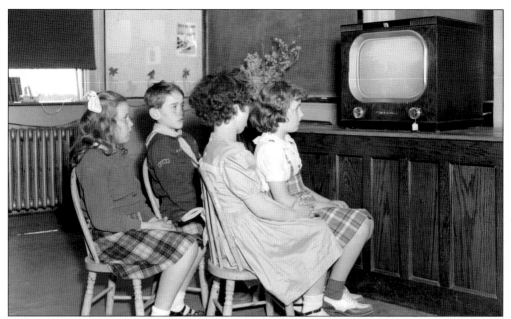

In 1950, students of Catherine Blumberg and Mary-Elinor McKenney enjoy the educational value of the relatively new technology of television. Watching a Mexican television program at the Cochesett School from left to right are Betty A. Benson, Richard E. Swan, Rena Lee Backlund, and Doris I. Breman. (Courtesy of the Stonehill College Archives and Historical Collections, Stanley A. Bauman Photograph Collection.)

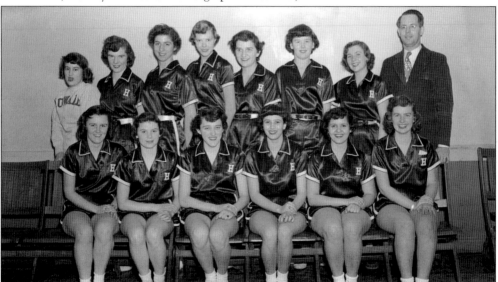

The 1950 Howard High School girls' basketball team was undefeated in an 11-game season. From left to right, members of the squad are (first row) Eleanor R. Turner, Patricia L. Leighton, captain Marilyn A. Marzelli, Dorothy E. Chaves, Antoinette M. Mazza, and Lee Caswell; (second row) student manager Barbara A. Barrows, Joan F. Marchant, captain-elect Barbara Asack, Nancy M. Rosnell, Gerry A. Grippen, JoAnne R. Welch, Jean M. Willis, and coach Roger G. Viens. (Courtesy of the Stonehill College Archives and Historical Collections, Stanley A. Bauman Photograph Collection.)

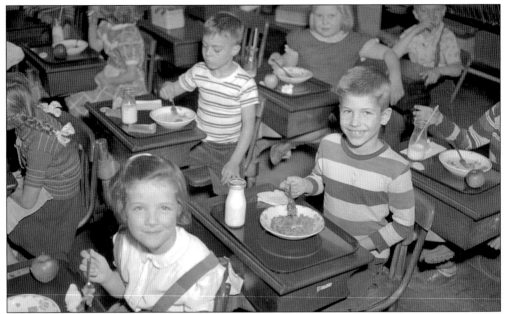

Today it is taken for granted, but a hot school lunch was a novelty in 1950 when the students of the Matfield School were treated to their first such meal. The program was launched in cooperation with the school department and parents. In this photograph Carolyn E. Fisher and Linwood K. Thompson Jr. enjoy the new fare. (Courtesy of the Stonehill College Archives and Historical Collections, Stanley A. Bauman Photograph Collection.)

Unique in its design and reminiscent of an Alaskan landscape dotted with igloos, the Spring Street Elementary School opened in September 1956. This school replaced the old wood-frame buildings that served the town faithfully for years. The igloos were actually skylights located in each classroom. Today the building houses the administrative offices of the school department and other programs. (Courtesy of the Stonehill College Archives and Historical Collections, Stanley A. Bauman Photograph Collection.)

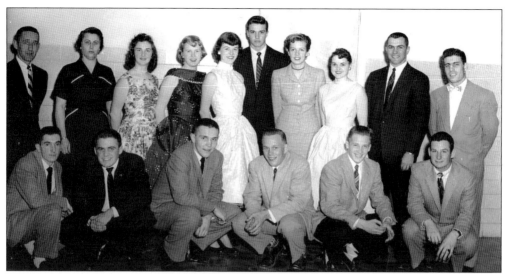

On April 16, 1956, the team captains of West Bridgewater High School were honored along with their coaches. From left to right are (first row) James Mullins and Peter Reed, football; William Allen Jr. and George Perry, baseball; and Edward Sinkevich and F. Earle Caswell, football for 1957; (second row) Leon Gleason, coach of basketball; Phyllis Jordan, girls' coach; Edith Bailey and Janet Lendh, basketball; Judith Nelson, head cheerleader; Forrest Broman, 1957 basketball; Judith Pierce and Judie Nickerson, softball; Victor Bissonnette, assistant football coach; and Bino Barreira, football and basketball coach. (Photograph by Stanley A. Bauman, courtesy of Forrest Broman.)

The Sunset Avenue Parent-Teacher Association presented the school with a portable television set in 1958, a headline-making story at the time. From left to right are superintendent Bert Merrill; Mrs. Patrick McDonough, association treasurer; Peter N. Gezotis, association president; and school principal Margaret Boynton. (Courtesy of the Stonehill College Archives and Historical Collections, Stanley A. Bauman Photograph Collection.)

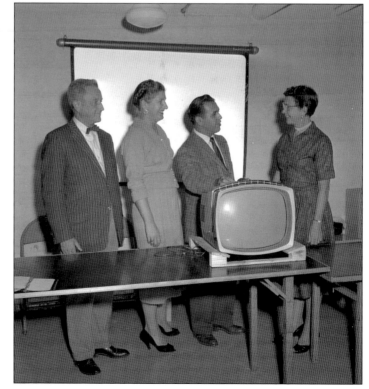

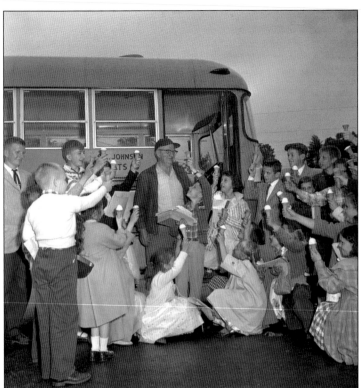

Samuel C. Johnson began driving a school bus in 1920 and transported students from Jerusalem and Cochesett to school on a daily basis. As was his yearly custom, in 1958 on the last day of school, Johnson stopped the bus in Elm Square and treated 109 children to an ice-cream cone. A group of delightful youngsters raise their cones in thanks. (Courtesy of the Stonehill College Archives and Historical Collections, Stanley A. Bauman Photograph Collection.)

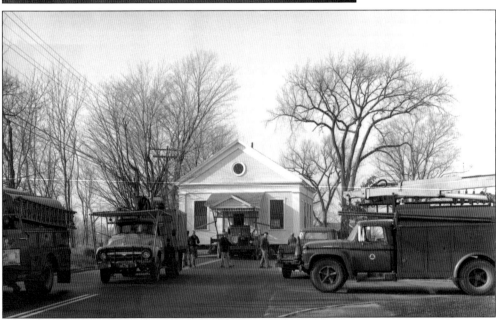

In 1962, to make way for the west wing addition to the high school, which would include a new state-of-the-art home for the West Bridgewater Public Library, the old Center Primary School, which had been home to the library since October 1908, had to be moved. The new library was built at a cost of $64,000. (Courtesy of the Stonehill College Archives and Historical Collections, Stanley A. Bauman Photograph Collection.)

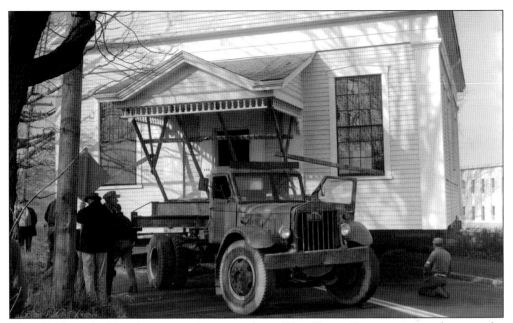

The old library building begins its slow move down West Center Street to its new home at the corner of South Main and Ash Streets. The building was purchased by Kenneth Wood to house his growing business, Kenwood Tire Company. With a few modifications, the building retains much of its classic schoolhouse look to this day. (Courtesy of the Stonehill College Archives and Historical Collections, Stanley A. Bauman Photograph Collection.)

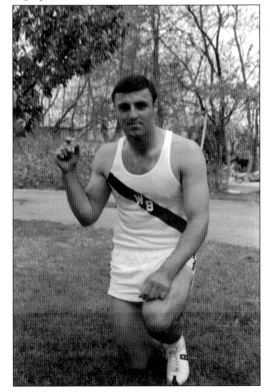

West Bridgewater High School produced many quality athletes, including Philip Asack. In May 1967, Asack set a new state record in the 180-yard low hurdles in a Class E state meet. Asack went on to be a football star at Duke University and played professionally for the San Diego Chargers. (Courtesy of the Stonehill College Archives and Historical Collections, Stanley A. Bauman Photograph Collection.)

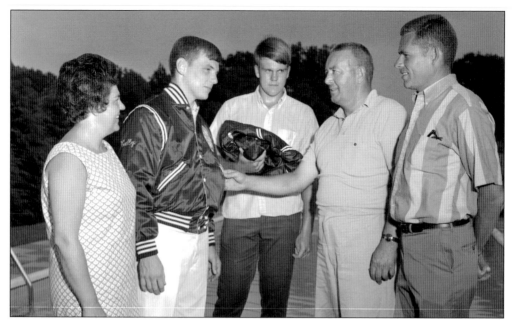

On August 2, 1968, jackets were presented to the baseball team by the West Bridgewater Boosters Club during a splash party at the home of team member Edward S. Zamaitis. From left to right are Elizabeth Zamaitis, hostess; Carl R. Ohlson, captain; Zamaitis; William Johnson, booster president; and Al Rapp, coach. (Courtesy of the Stonehill College Archives and Historical Collections, Stanley A. Bauman Photograph Collection.)

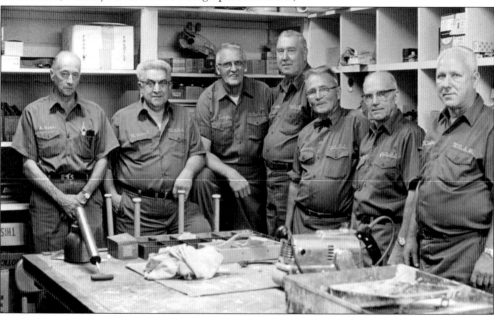

West Bridgewater High School's custodial staff, pictured from left to right in their shop, includes Gordon K. Ross, Henry Marcot, John Large, Gilbert Anderson, Warren A. Turner, Myron Mather, and Robert Nordgren. Turner was instrumental in the establishment of the school's boosters club and dedicated years of service to its success in supporting the town's athletes. (Courtesy of Warren E. Turner.)

Three

AGRARIAN ENDEAVORS

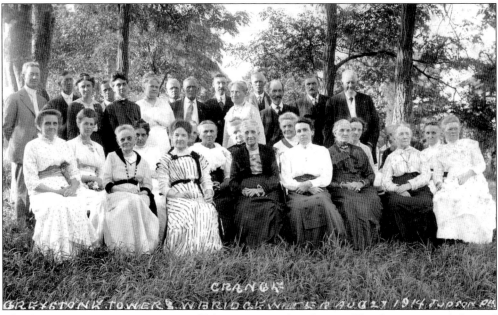

The Grange was an important part of life in an agricultural town. The Grange provided social activities as well as education of the best agricultural practices. In this photograph on the far left in the back row is Dr. Ellis Sweetlove LeLacheur, owner of Greystone Towers, and at the far right in the same row is Samuel Godfrey Copeland, a well-known local farmer. (Courtesy of the West Bridgewater Public Library.)

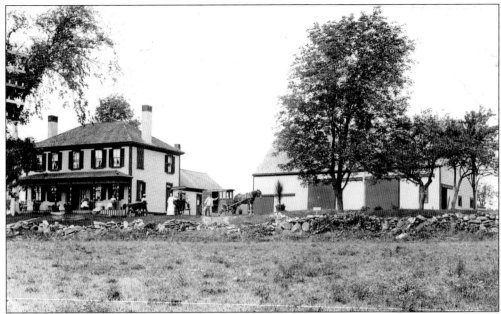

This view shows the stately Federal-style house and massive barn of Old Orchard Farm, located on West Center Street on the northeast corner of West Street. Many large homes such as this were demolished due to age, condition, and in the name of progress. This home was demolished to make room for Tedeschii's Convenience Store, now on the site along with other businesses. (Author's collection.)

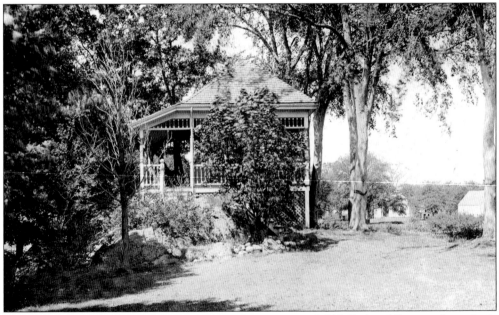

This Victorian-style summerhouse stood on the property of Old Orchard Farm and was built on a large outcropping of Roxbury pudding stone, which can be seen to this day alongside West Center Street near West Street. Roxbury pudding stone is the state rock of Massachusetts. This structure stood for many years on this spot and, according to local residents, was burned one Halloween evening. (Courtesy of David and Marilyn Raleigh.)

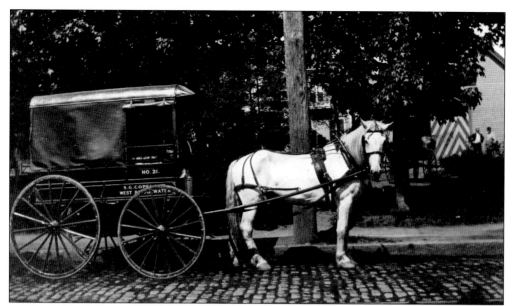

Among West Bridgewater's most prominent citizens in the later half of the 19th century was Samuel Godfrey Copeland. Copeland was both a dairy farmer, as evidenced by his milk wagon shown here, and a produce farmer located at the north end of the town. When Brockton annexed the north portion of the town in 1893, a large majority of Copeland's property was part of the transaction. (Author's collection.)

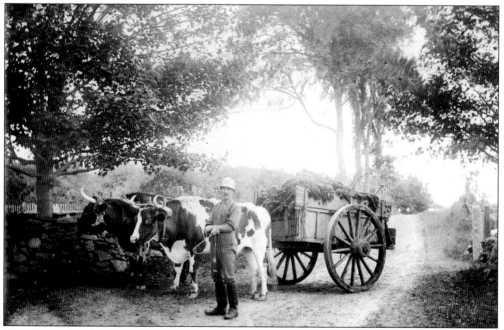

The Thayer family was for many years prominent in town affairs and owned considerable acreage and real estate in the East and Union Streets area. This 1890s image shows Joseph Thayer with an oxcart and a yoke of oxen. Joseph Thayer, who lived at 16 Union Street, was also a machinist and is reported to be the first West Bridgewater resident to own an automobile. (Courtesy of Duane Thayer.)

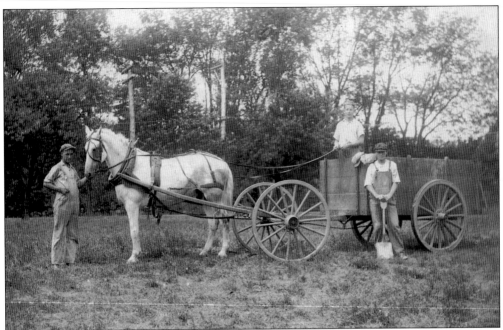

Howard Nickerson, with reins in his hand, poses for this photograph with two unidentified coworkers. Nickerson worked on the Ensher Brothers farm on Lincoln Street in the Cochesett section of town. Nickerson lived at 11 High Street and, like many local residents, was also a shoe worker. (Courtesy of Barbara Ouderkirk.)

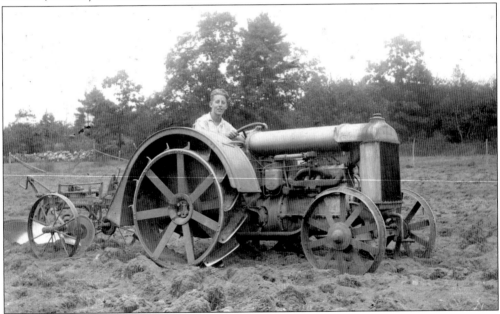

In the early 20th century, gasoline-powered behemoths such as this Ferguson tractor and its Oliver No. 7 plow, operated by Nickerson, replaced horse-drawn machinery. Providing more comfort, this modern equipment was able to do more work with less effort than its horse-drawn predecessors. As one can imagine, the weight and mass of this equipment was a drawback at times in the region's soft, boggy fields. (Courtesy of Barbara Ouderkirk.)

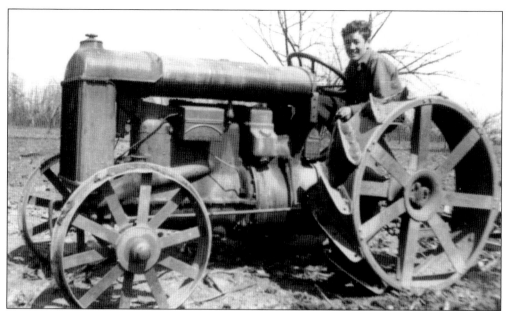

Walter Orr Roberts, who worked on his father's East Street farm, went far beyond the fields of West Bridgewater. Earning his doctor of philosophy degree at Harvard College in 1943, Roberts became the director of Colorado's High Altitude Observatory as well as a professor of astrogeophysics at the University of Colorado. He was founding president of the University Corporation for Atmospheric Research and the first director of the National Center for Atmospheric Research. (Courtesy of Jonathan Roberts.)

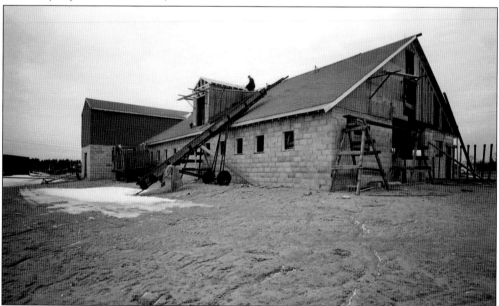

Howard Hayward works on a new barn in 1968 on the family farm on East Center Street. Hayward and his brother Layton were the last members of the family to operate the farm that had been run by the family since 1650. The barn and a portion of the farm's land were sold to Shaw's supermarkets in 1974. On July 9, 1979, the barn was destroyed by fire. (Courtesy of the Stonehill College Archives and Historical Collections, Stanley A. Bauman Photograph Collection.)

In about 1934, the Zeuli family purchased a farm at 167 West Center Street at the top of Bull Dog Hill. The farm consisted of approximately 100 acres, and its major produce crops were spinach, tomatoes, beans, squash, and cabbage. In this photograph, Alessandr Zeuli is sorting beans for market. During World War II when local labor was short, the farm hired men from Jamaica to live and work there. (Courtesy of Jennie Keith.)

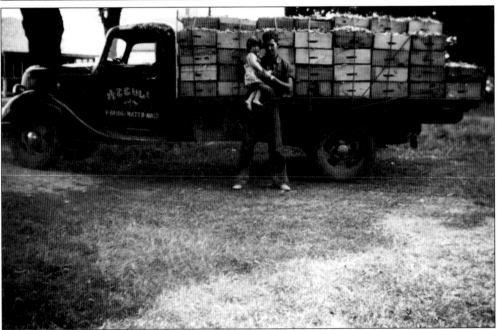

Stacked high with crates of produce, the Zeuli farm truck is ready to head to the produce market in Boston. The farm also had a greenhouse and a chicken house that held 1,000 chickens. In 1952, the state purchased the farm and bisected its acreage with Route 24, the new state highway, from New Bedford to Boston. (Courtesy of Jennie Keith.)

In the early 1930s, Francis D. Howe of Ash Street received a turkey as a gift and kept it as a pet. Hatching some of the turkey's eggs, which he did with success, Howe eventually became one of the town's first turkey farmers with over 1,000 birds at a time. He was very active in the Lions Club, and the skating rink on Howard Street is named in Howe's honor. (Courtesy of Barbara Howe MacQuinn.)

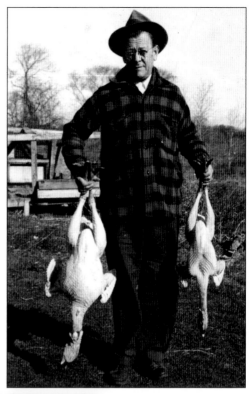

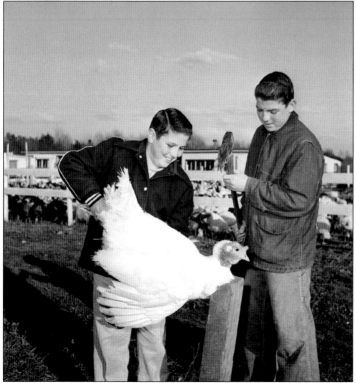

Edward G. and Louise Asack began a turkey farm on South Street that continues to be operated by the Asack family. In this November 17, 1955, photograph, Edward G. Asack Jr., left, and Donald G. Asack prepare to "give the axe" to a fattened turkey in time for the Thanksgiving holiday. (Courtesy of the Stonehill College Archives and Historical Collections, Stanley A. Bauman Photograph Collection.)

69

$75. 1906

West Bridgewater Aug 1
Rec'd of John W Darling
Seventy five dollars
full pay mt for one
horse named Mike
owned by F. M. Shaw

Prescott Snell

John W. Darling was a local teamster who cut wood in towns as far away as Halifax and Middleboro for the box factories in Brockton. This receipt indicates that he bought a horse named Mike owned by an F. E. Shaw from Prescott Snell for $75. Snell was a local farmer whose ancestral home was at the corner of Spring and North Elm Streets. (Author's collection.)

Hill's Gladiolus and Dahlias

601 East St. - West Bridgewater

Tel. 454 M-2 Brockton

In addition to dairy farmers and market gardeners, there were several farms in West Bridgewater that were known throughout the region for their flowers. Among them was Hill's at 601 East Street and Thomas Blundell on East Center Street. Another well-known grower was William Heywood and his wife, Viola, who raised dahlias at 609 East Street. Heywood was also the signalman for the railroad crossing on East Street. (Author's collection.)

In 1912, Alphonse J. Pillsbury, a painter by trade, founded Pillsbury's Greenhouses at 506 North Elm Street. The business began in the large barn that was on the property. In 1922, his son Frank Pillsbury, pictured here with the barn in the background, took over the business and expanded it to include seven greenhouses. (Courtesy of Carol Rio.)

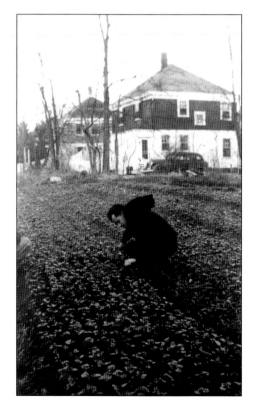

Many local florists grew their own flowers in season. Pictured here is Frank's son-in-law George A. Earle Jr. weeding seedlings on land adjacent to the greenhouses. Today most of this land has been developed, and most florists buy from the large flower wholesale companies. Pillsbury's, now in its 98th year of business, is under the operation of Carol Rio and has a second location in East Bridgewater. (Courtesy of Carol Rio.)

71

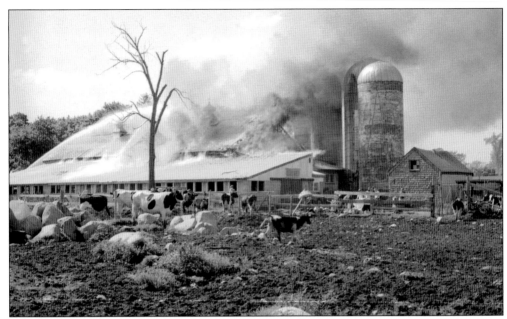

Fire is one of a farmer's worst nightmares. Because of their sheer size and openness, barns are rarely saved once engulfed by fire. In the spring of 1966, the Chisholm farm on East Street was consumed by fire. This photograph shows thick smoke billowing from the barn as firefighters from several towns battle to control the flames. (Courtesy of the Stonehill College Archives and Historical Collections, Stanley A. Bauman Photograph Collection.)

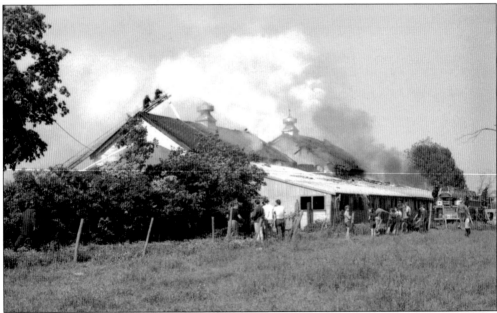

Neighbors assisted the owners and farmhands in rescuing over 100 cows from the conflagration. The farm was owned by the Chisholm family for many years and prior to their ownership was owned by brothers Anders and Aaron Anderson and Anders's son Elmer. The farm had also once been part of the Thayer family farm. (Courtesy of the Stonehill College Archives and Historical Collections, Stanley A. Bauman Photograph Collection.)

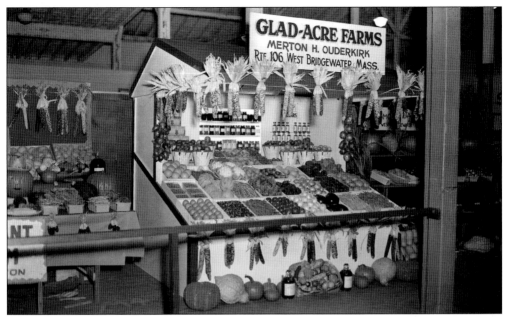

The Brockton Fair held annually by the Brockton Agricultural Society was a place where local farmers could display the best of their crops and solicit business from local residents. In this 1949 image, the Glad-Acres Farmstand, owned by Merton H. Ouderkirk, neatly displayed the West Center Street farms' best produce. (Courtesy of the Stonehill College Archives and Historical Collections, Stanley A. Bauman Photograph Collection.)

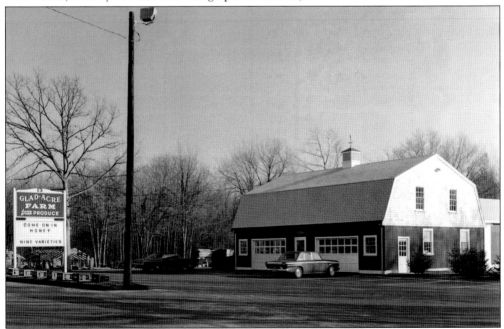

Beginning as a small roadside stand known as Mert and Larry's and then Glad-Acres Farmstand, the establishment grew, and in 1969, a new, enlarged roadside market was built. After Ouderkirk and his wife, Barbara, retired, the property was sold and developed into a small strip mall, maintaining the Glad-Acre name. (Courtesy of Barbara Ouderkirk.)

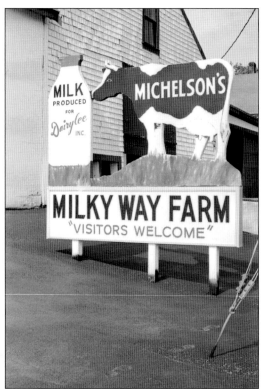

The Milky Way Dairy, located on Bulldog Hill in Cochesett across from what are now the corporate offices of Shaw's supermarkets, was once owned by the Cheyunski brothers. Later, known as Milky Way Farm, it was owned by the Michelson brothers, who introduced the latest dairy farm technology into the business in 1968. Adolph Cheyunski also operated Ace's Service Station adjacent to the farm for many years. (Courtesy of the Stonehill College Archives and Historical Collections, Stanley A. Bauman Photograph Collection.)

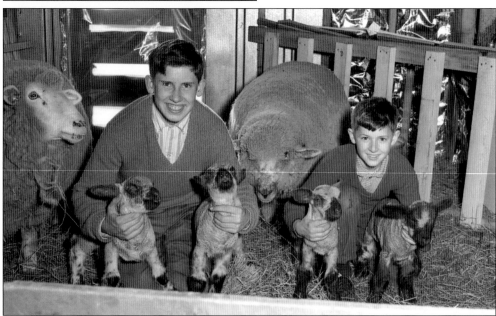

Many young people grew up in West Bridgewater with some type of farm animal and were members of local agricultural organizations. In this February 15, 1967, photograph, Union Street residents Stephen Allen, right, and his brother Peter and members of the Sachem Woolies 4-H Club tend to sets of twin lambs. (Courtesy of the Stonehill College Archives and Historical Collections, Stanley A. Bauman Photograph Collection.)

In this 1951 image, George O. Asack, age 81, is shown working in his garden on Brooks Place. Even at this advanced age, Asack worked 15-hour days, splitting his time between his farm and the variety store his family operated at the corner of Brooks Place and North Elm Street. (Courtesy of the Stonehill College Archives and Historical Collections, Stanley A. Bauman Photograph Collection.)

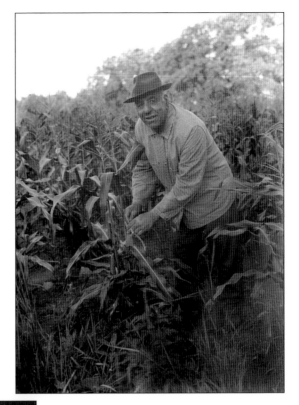

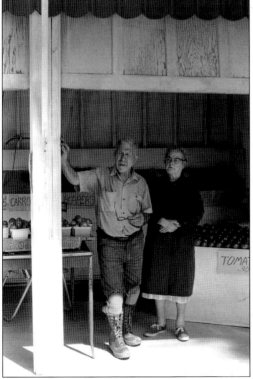

In 1972, 85-year-old Joseph Falzarano, a retired West Bridgewater Water Department worker, still managed his large vegetable farm on Union Street. Shown here with his wife, Gladys, in their small farm stand, they were well known in the area for quality produce and fair prices. (Courtesy of the Stonehill College Archives and Historical Collections, Stanley A. Bauman Photograph Collection.)

PURE MILK FROM TUBERCULAR TESTED COWS UNDER STATE AND FEDERAL SUPERVISION

WEST BRIDGEWATER, MASS.,_____194__

M_____

TO **WILLIAM W. PHILLIPS**, DR.

TEL. 207M2 ◆ MEADOWBROOK DAIRY

TO BILL RENDERED..	$..............
TO..............QUARTS OF MILK AT....................CENTS PER QUART	$..............
TO..............PINTS OF MILK AT.......................CENTS PER PINT	$..............
TO..............JARS OF CREAM AT......................CENTS PER JAR	$..............
TO...	$..............
TOTAL	$..............
RECEIVED PAYMENT.. AMOUNT PAID	$..............
BALANCE	$..............

J. S. FOGG PRESS, 40 LENOX ST., BROCKTON, MASS. 622

Meadowbrook Dairy, operated by William W. Phillips, was located along West Center Street in the Cochesett section of West Bridgewater along the banks of the West Meadow Brook and Flaggy Meadow. Tuberculosis and its connection to sick cows was still such a concern that even the billhead emphasized disease-free milk. (Courtesy of Margaret Phillips Silva.)

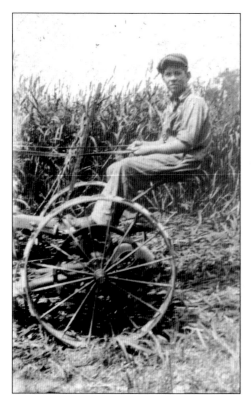

Work on the farm began at a young age, as shown in this 1922 photograph of Ivan Carlson in the seat of a horse-drawn harvesting machine on the farm owned by his father, Carl P. Carlson, on the upper end of Brooks Place. Ivan eventually ran the farm and made deliveries around town with his dog Booze. (Courtesy of Margaret Phillips Silva.)

Four

BUSINESS AND COMMERCE

This view of George R. Drake's store at the corner of North Main and West Center Streets was taken from South Main Street in the early part of the 20th century. This store was operated by various people and under a variety of names over the years, including Orvis Kinney, Kirby's, Crowley's, and West Bridgewater Pharmacy. (Courtesy of the West Bridgewater Public Library.)

This view looks east down West Center Street from the center with George R. Drake's store on the right and the trolley on the left. The sign in the lower left store window advertises Moxie. As was the case in many stores at the time, the owner lived above it. After Drake's death in 1906, his son George S. operated the store until his death in 1926, at about which time Orvis Kinney assumed ownership of the firm. (Courtesy of the West Bridgewater Public Library.)

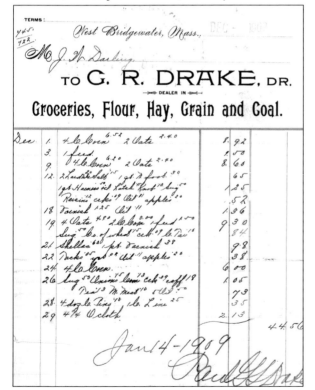

A 1908 billhead from the Drake's store indicates the great variety of products that were in its inventory. On this bill, items purchased by John Darling include oats, corn, raisins, lard, varnish, shellac, four dozen common pins for 10¢, four and a quarter yards of cloth, apples, and a quart of harness oil for 50¢. The monthly bill, totaling $44.56, is marked paid and signed G. S. Drake. (Author's collection.)

The quintessential small-town pharmacist, David Cohen was a fixture for many years in the former Drake's store. Cohen's West Bridgewater Pharmacy was the place to go for prescriptions and also for some of the proprietor's own compounds and cough syrups. Cohen was a strong supporter of various programs and activities in the town. (Courtesy of Susan Cohen Bickoff.)

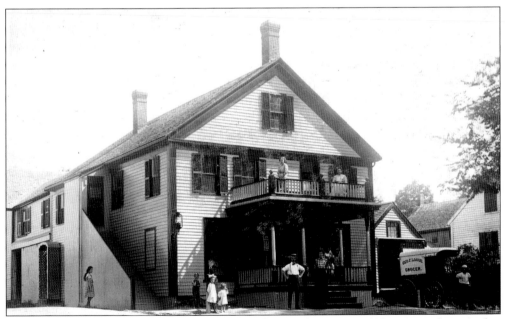

George Logue's store in Cochesett dates back to about 1850. For over 100 years, it also served as the Cochesett Post Office. It has also operated under the names of Straffin, Andre, and Andre's. Joseph Andre served as postmaster for over 33 years, having been appointed in 1923 under Pres. Calvin Coolidge's administration. This building is today home to Bloom's Pizza. (Courtesy of David and Marilyn Raleigh.)

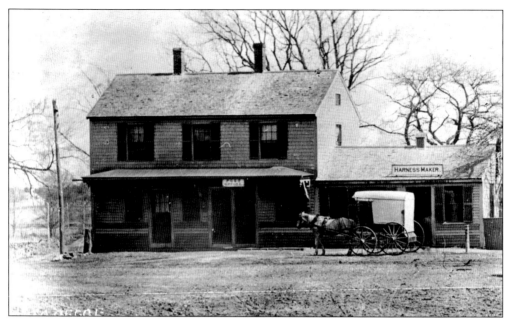

This building, located at the corner of River and South Main Streets, is the first known location of a post office in West Bridgewater. This building was sold to Edwin Lothrop, who relocated it on River Street. It was then sold to Eddy Dunbar, who moved it to Bryant Street, where it was owned by the J. Robert Gummow family. The building housed a harness maker as well. The wagon belonged to Stillman Alger. (Author's collection.)

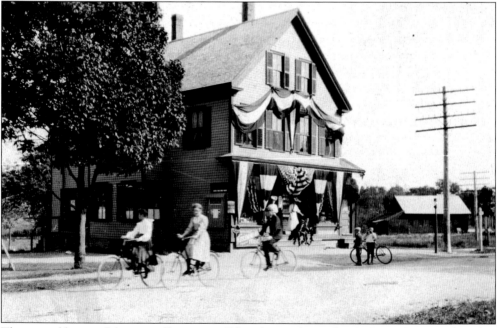

The second home of the post office was in Gibson's store located at 22 River Street. When first established, the post office was a fourth-class office. In 1920, it became third class, and in 1949, it advanced to become a second-class office. The oldest records available, from 1884, show that the post office did an annual business of $300. (Author's collection.)

No. Post Office, **West Bridgewater, Mass.**

.................... **DEC 20 1911**...., 191

Mr. E. C. Newcomb

To **RENT OF BOX No.** _48_ for Quarter

ending **MAR 31 1911**....., 191 , $......_.15_.....

Received payment, _B. F. Packard._

BRING THIS BILL WITH YOU.

See Regulations on other side. **Postmaster.**

This 1911 post office box receipt indicates the rental fee was 15¢ per quarter and is signed by Burton F. Packard, who became postmaster that year. The first postmaster was Jarvis Burrell. Others included Charles Packard, Rufus Bennett, George Howard, and William E. Gibson, who served from 1914 until 1934. John Kent was appointed in 1934 and oversaw the move of the post office to its current location. (Author's collection.)

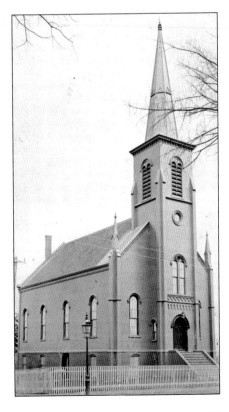

In 1870 in North Bridgewater (Brockton), the First Swedish Evangelical Lutheran Church became the first church built in New England by Scandinavian immigrants. Erected at the corner of Nilsson and Main Streets, the building was designed and constructed by West Bridgewater architect Samuel Ryder. This building was razed in 1922 to make way for the church's new edifice. (Courtesy First Evangelical Lutheran Church.)

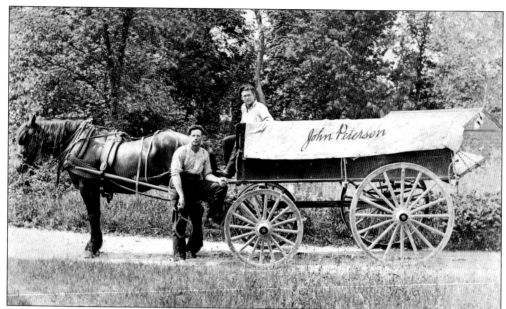

Before the days of modern refrigeration, the icebox and the iceman were a routine part of life. The iceman delivered various sized blocks of ice to local homes and in many cases walked into the house and put the ice directly into the icebox. In this photograph, John Peterson is seated on the wagon and Walter West is standing by the wagon with ice tongs in hand. (Author's collection.)

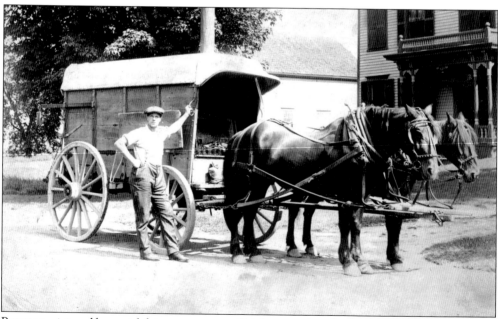

Peterson, pictured here with his team, operated his business from his home on Roosevelt Avenue. Ice was procured from the local ponds and wholesale icehouses and delivered to local homes and businesses. Note the arm and scale hanging on the side of the wagon to weigh the blocks of ice. Another well-known local iceman was Gordon K. Ross. (Author's collection.)

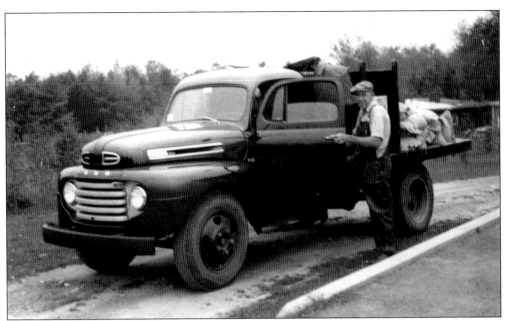

Every local farmer relied on a source of feed and farm supplies, and one person who could be depended on to deliver those services was Carl V. Nelson of Brockton. He managed the West Bridgewater Grain Company located at the railroad depot in the wood-frame building in the current Turner Steel Complex. Nelson had also been employed for many years as a driver for the Brockton-Taunton Lumber Company. (Courtesy of Marian E. Nelson.)

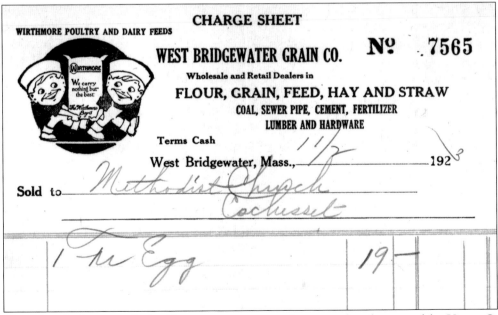

The West Bridgewater Grain Company was at one time owned and operated by Henry O. Davenport and his wife, Alma, who lived on the upper end of Spring Street. Davenport had been a dairy farmer, contractor, and truck driver. It is said that "he possessed a vocabulary of picturesque words seldom heard in polite society." Davenport was also a town selectman and the first chief of police. (Courtesy of Karolyn Boyd.)

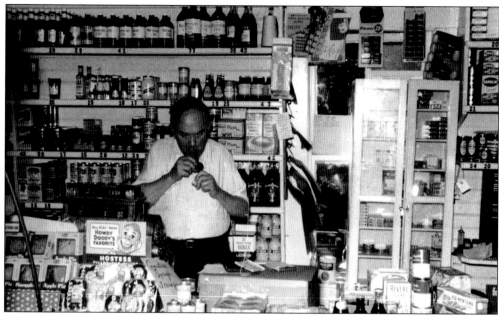

Ernest Lindgren is seen behind the counter of the well-stocked family store at 362 North Elm Street. Established in 1925, the store was run by Lindgren's wife, Bertha, while he worked in a Brockton shoe factory. Small neighborhood stores such as this were the backbone of the community, and almost everyone lived within walking distance of such an establishment. (Courtesy of Robert E. Lindgren.)

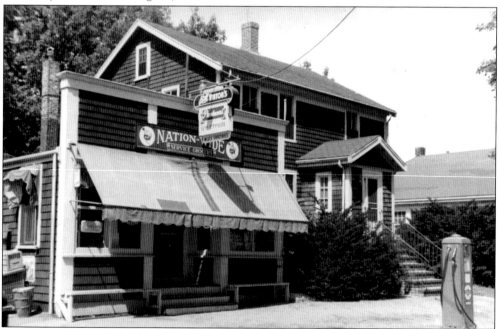

In 1953, Lindgren's store became Bill Vinton's Nation Wide. Many of these local markets sold everything from candy to gasoline. During hard times, owners of these stores, often to their own detriment, extended credit to their customers and had a "pay as you can" philosophy. (Courtesy of Robert E. Lindgren.)

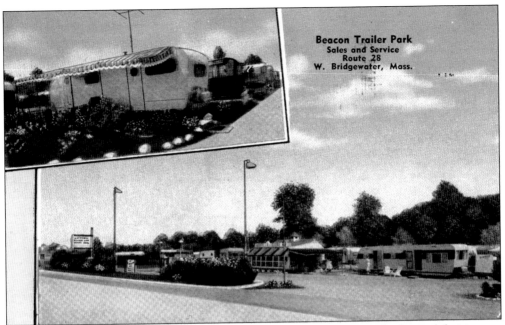

In the postwar years, housing in America took on a new look from suburban subdivisions to manufactured housing. This 1954 postcard shows the new Beacon Trailer Park at 855 North Main Street. The message on the card states, "I went through two of these trailers over at the fairgrounds last week. Very attractive and cost only a bit over $5,000.00." (Author's collection.)

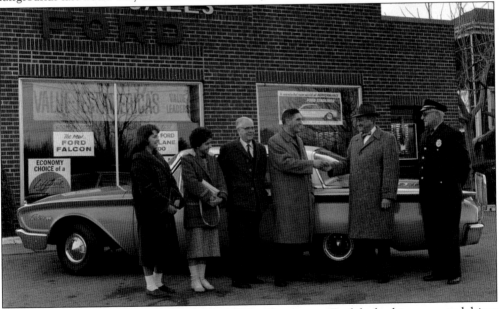

In 1959, Julian "Jiggs" Lucini of Lucini Motor Sales Company, a Ford dealership, presented driver education cars to West Bridgewater, East Bridgewater, and Bridgewater. Here receiving the West Bridgewater car from left to right are students Carole Greene and Andrea Giovanoni, instructor Floyd Folsom, Lucini, school superintendent Bert Merrill, and Chief P. Douglas Eaton of the police department. (Courtesy of the Stonehill College Archives and Historical Collections, Stanley A. Bauman Photograph Collection.)

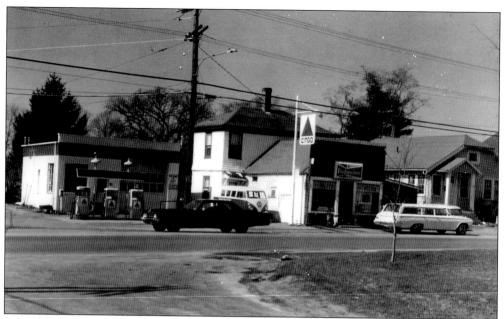

A local landmark, the store on Richard's Corner at 4 Plain Street has been known over the years as Dill's, Peterson and Bennett's, Richard's Corner Market, and Tri-Town Variety, among others. In 1949, Julian "Cy" Hughes and Robert Larkin bought the store from Walter and Bill Crowley, and in 1965, Hughes bought Larkin's share. Hughes operated the store until his death in 1984. (Courtesy of the Julian S. Hughes collection.)

In 1962, the Amerigian family opened its new Hockomock Farms store, a state-of-the-art grocery store in Elm Square. The family had operated a smaller facility at the same location for a number of years. Well stocked and equiped with wide, bright aisles and its own meat department, the store combined old-fashioned neighborhood service with a modern setting. (Courtesy of the Stonehill College Archives and Historical Collections, Stanley A. Bauman Photograph Collection.)

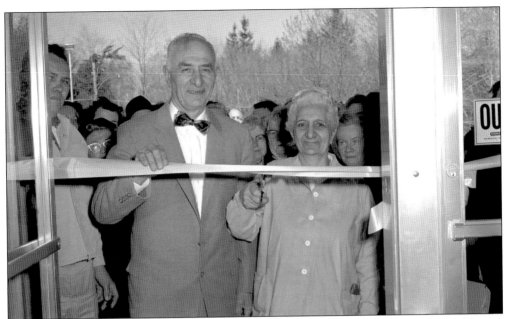

In this May 6, 1962, photograph, Aris Amerigian and his wife cut the ribbon to open his new grocery store. This new facility and Trucchi's Supermarket in the center of town indicated that the end of the small neighborhood store was in sight, although a few have survived, including the Matfield Corner Market, formerly Belmore's, A. A. DiFrancesco's, and Matti's. (Courtesy of the Stonehill College Archives and Historical Collections, Stanley A. Bauman Photograph Collection.)

In the early 1960s, West Bridgewater launched a campaign to bring new business to town. In this photograph dated May 25, 1961, the board of selectmen celebrates the opening of the TriS gasoline station in Elm Square. Pictured from left to right are Douglas Bone, selectman Merton Ouderkirk, Marjorie MacDonald, George Hollertz, and a Mr. Griffin. (Photograph by Stanley A. Bauman, courtesy of Barbara Ouderkirk.)

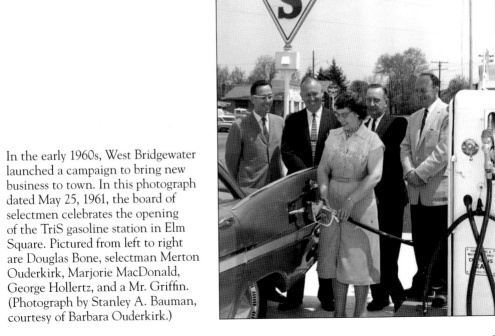

This Christmas card from Dr. Adolor O. Belmore and his wife shows the beauty of the landscaping at their home on South Main Street. Belmore donated $5,000 toward the construction of the town's Roman Catholic church and was given the honor of choosing the name of the parish. He chose St. Ann, in memory of his wife, Anna T. Belmore. (Author's collection.)

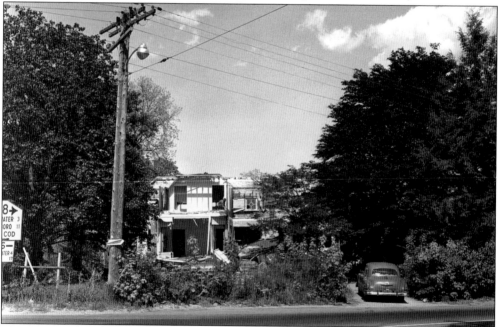

The estate of Dr. Adolor O. Belmore stood at 4 South Main Street in the triangle created by the intersection of East Center and South Main Streets. Belmore served several generations of town citizens as their physician and maintained his offices in his home. This home was demolished in 1962 to make way for a shopping center, the town's first. (Courtesy of the Stonehill College Archives and Historical Collections, Stanley A. Bauman Photograph Collection.)

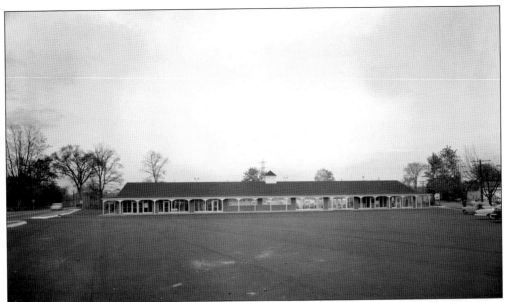

On the former Belmore property in 1962, the Center Shopping Plaza, developed by the Pagani family, consisted of eight stores. The anchor of this new complex was Trucchi's Supermarket, today located on the site of the former Gustaf Peterson's Riverview Farm on East Center Street. The complex was also home to Pomeroy's Donut Shop, Daiker's Florist, and others. (Courtesy of the Stonehill College Archives and Historical Collections, Stanley A. Bauman Photograph Collection.)

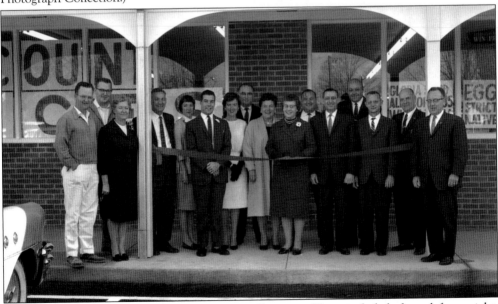

Those attending the opening of the Center Shopping Plaza included, from left to right, Harry Pomeroy, Joseph Pomeroy, Mrs. Herman Daiker, Herman Daiker, Carol Walker, David Walker, Kathleen Neafsey, Mr. and Mrs. Hugh Kelley, Marjorie MacDonald, Nando Pagani, William Trucchi, Arthur Pagani, O. Howard Worsham, John Eldridge, and Frank Miller. (Courtesy of the Stonehill College Archives and Historical Collections, Stanley A. Bauman Photograph Collection.)

Alberg
TYPHOON
BY
CAPE DORY

L. O. A.—18'-3½"
BEAM—6'-3½"
L. W. L.—13'-6"
DRAFT—2'-6"
DISP.—1750 Lbs Approx
S. A.—160 Sq Ft

Expertly designed by Carl Alberg and superbly constructed by Cape Dory Co., Inc. the Alberg Typhoon is an exceptional day sailer and racer with a true yacht-like feel and appearance whether under sail or at the mooring.

A full wine glass shape keel with 900 lbs. of lead solidly encased within her hull makes the Typhoon a family-safe boat. Her large cockpit affords ample room for a racing crew and the extra wide cockpit coaming assures comfort for extended day sailing or short cruises. Her cabin provides two full berths — large storage compartments and room for a marine toilet.

Cape Dory uses only the finest construction materials as well as employing the greatest care in the crafting of the fiberglass hull. A fine blend of bright finished mahogany and quality fiberglass molding.

Standard equipment includes aluminum spars with roller-reefing stainless steel standing, dacron halyards and running rigging. All deck hardware including genoa gear and winches. Berth cushions, cradle, antifouling bottom and boot top. Specially molded-in mahogany transom is also standard.

Cape Dory does not compromise in any phase of boat building and is proud to make this addition to their present line of quality boats.

Marine toilet	$140.00
Outboard bracket	55.00
Cockpit cushions	
Cockpit cover	Prices on
Spinnaker gear	request

Main	$150.00
Jib	100.00
Genoa	135.00

Sails by Dyson of Marblehead

COLORS — HULL & DECK WHITE ONLY — NON SKID DECK AREA LIGHT BLUE

$2995.00 less sails. F.O.B. West Bridgewater, Mass.

Prices and specifications subject to change without notice

The Cape Dory Company, founded by Andrew Vavolotis, was located at the corner of Crescent and West Streets on the site of the former Peter's Barrel Company and the Cochesset railroad station. Several thousand sailboats were made in this facility, ranging up to 45 feet in length. The Cape Dory *Typhoon* was designed by Carl Alberg and has been called "America's littlest yacht." One of the most popular sailboats built, Alberg described the *Typhoon* as "ageless with perpetual value." The Cape Dory Company eventually moved to East Taunton, and Vavolotis is today affiliated with the Robinhood Marine Center in Georgetown, Maine. (Courtesy of Andrew Vavolotis.)

90

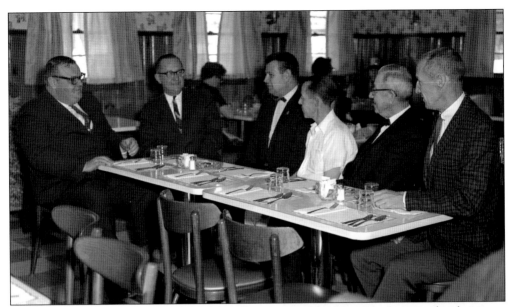

The Steer Club Restaurant on North Main Street was a favorite eatery for many local citizens. Celebrating the grand opening from left to right are David Bourget, Bourget Company; George Hollertz, board of selectman chairman; Bruce Soderholm, Steer Club president; Robert McCarthy, manager; Hjalmar Soderholm, Hillcrest Dairy treasurer; and Randolph Barker, Component Manufacturing Company. (Courtesy of the Stonehill College Archives and Historical Collections, Stanley A. Bauman Photograph Collection.)

Three generations of the Soderholm family opened Dutchland Drive Thru on December 8, 1967. Located on North Main Street, the store is still operating today, providing customers with the convenience of drive-through shopping for items such as milk, bread, cigarettes, and so on. From left to right are founders Bruce Soderholm, Hjalmar Soderholm, and Bruce Soderholm Jr. (Courtesy of the Stonehill College Archives and Historical Collections, Stanley A. Bauman Photograph Collection.)

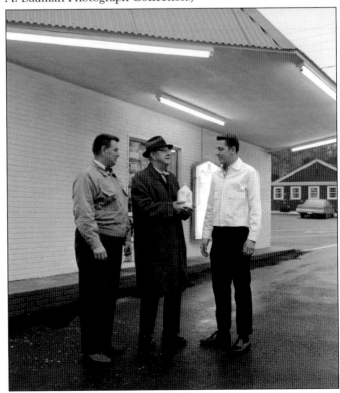

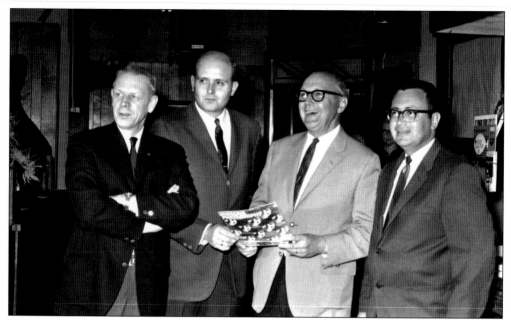

In May 1969, sporting goods store Tight Lines opened on South Main Street. The store specialized in the sale of hunting, fishing, and camping equipment, as well as sportswear, footwear, and accessories. Pictured here from left to right are Arthur Chase, treasurer; William Bassett, president; Gunnar Reis, manager; and Harry Koblantz, salesman. (Courtesy of the Stonehill College Archives and Historical Collections, Stanley A. Bauman Photograph Collection.)

In 1974, Loring B. Anderson opened Swede's Bakery on South Main Street, specializing in Swedish pastries, breads, and other delicacies. He spent part of his life in Brockton and on Matfield Street where his parents, C. Herman and Agnes Anderson, lived. For many years, he operated the Cities Service gasoline station at Perkins Avenue and Montello Street. (Courtesy of the Stonehill College Archives and Historical Collections, Stanley A. Bauman Photograph Collection.)

Five

AROUND THE TOWN

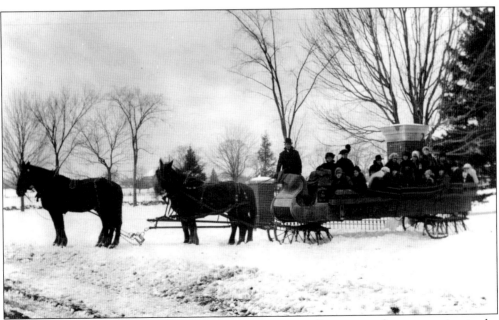

Even with the advent of the automobile, horsepower was still a means of transportation in the early 20th century. Sitting in front of the Howard Seminary gates, this large sled with its four-up hitch and passengers was owned and operated by the well-known Brockton teamster outfit of James Powers and Son. (Courtesy of the West Bridgewater Public Library.)

Mud and ruts in the springtime were commonplace, and even the main roads were not paved. This view of West Center Street looking west gives a good indication of road conditions that both automobiles and horses and wagons had to deal with. Local residents, their horses, and equipment were often hired to maintain the town's roads. Note the trolley track to the left side of the photograph. (Author's collection.)

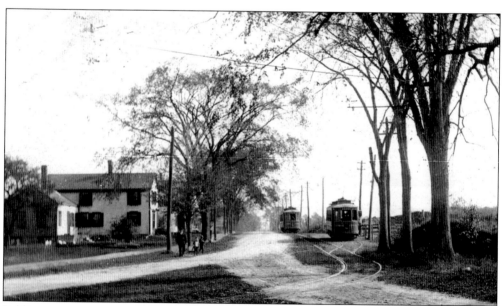

Public transportation was commonplace in many of the region's towns in the years preceding World War II. Here two trolleys are pictured on West Center Street coming into Elm Square. North Elm Street goes off to the left. The triangular piece of land in the foreground was known as Morse's Corner until 1902 when the name was changed to Elm Square. (Author's collection.)

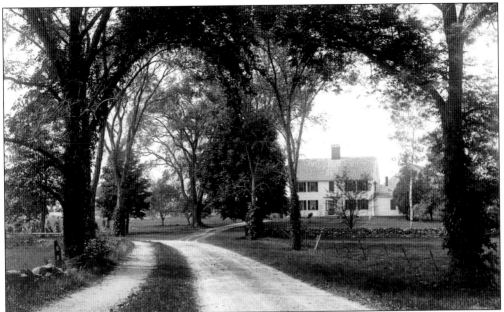

This house at 113 Howard Street was built by Capt. Eliakim Howard, a Revolutionary War officer. Born in 1739, Howard was town clerk and treasurer of Bridgewater from 1779 until 1822 when the towns were divided. He died in 1827. Father of 14 children, he operated a gristmill on the site of the town's first mill erected by Samuel Edson. (W. W. Bolton Photograph from *Descendants of John Howard* by Heman Howard.)

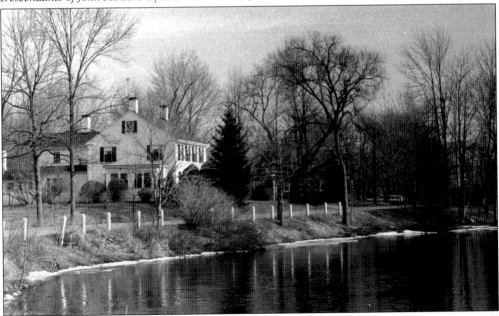

Jonathan Howard was a soldier in the Continental army and served at West Point in 1780 as well as in Capt. Adam Bailey's company and Col. John Bailey's 2nd regiment. Jonathan was born in 1748 and died in 1805. He and his wife, Martha Willis, had six children. His house, built in 1677, was later home to the YMCA, the Americanage Canoe Club, and United States congressman Hastings Keith. (Courtesy of Carolyn Keith Silvia.)

Complete with well-maintained outbuildings, this is the backyard of 16 Union Street as it appeared in about 1890. This property was a part of the estate of Joseph Kingman and was owned by Joseph Thayer at the time that this photograph was taken. Following in the footsteps of his father, Erland, Joseph Thayer and his brothers Ernest, Edwin, and Chester were active in town government throughout their lives. (Courtesy of Duane Thayer.)

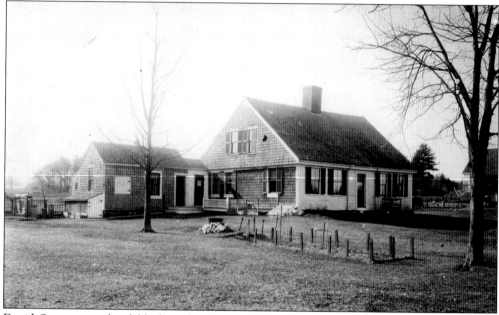

David Snow was a local blacksmith who resided in this cape on Copeland Street near the corner of Grant Street. Snow was a blacksmith who operated his trade at the same location. His son was Albert C. Snow, a shoemaker who lived on Forest Street next to Pratt's Bridge and operated a group of small cottages along the Town River. (Courtesy of the West Bridgewater Public Library.)

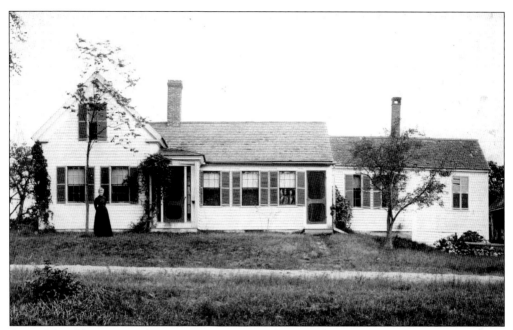

One of the oldest existing homes remaining in Cochesett village is at 11 High Street. Cochesett was an active manufacturing area of the town with the major industry being that of the Alger Foundry. Cochesett had its own railroad station and post office and was on the stagecoach line from Taunton to Boston. (Courtesy of Karolyn Boyd.)

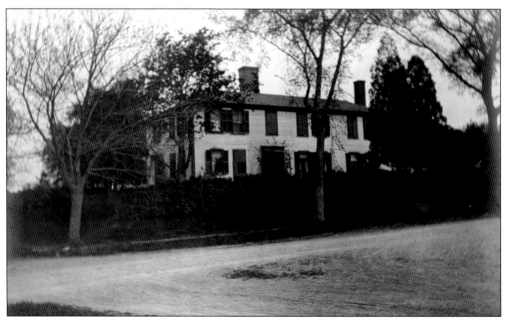

The large home in this photograph is at the corner of East and East Center Streets and at one time served as a tavern. Although Federal in style, this house boasts several entrances and an unusual window layout for the period, the result of possible renovations. Located close to the Westdale railroad station, it was also on the main route to Joppa Village in East Bridgewater. (Courtesy of Jac MacDonald.)

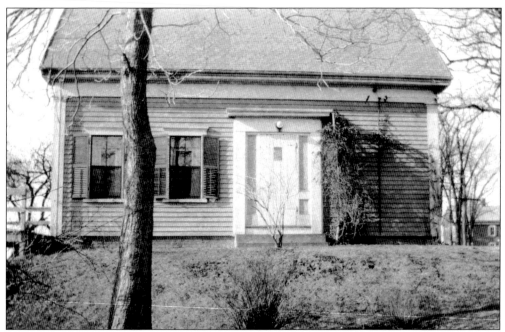

In earlier times, businesses were located in neighborhoods close to the homes of the owners and workers. This home at 327 East Street was at one time a cobbler shop owned by members of the Rider (Ryder) family. The East Street school was located a couple of buildings north at what is today 285 East Street. (Author's collection.)

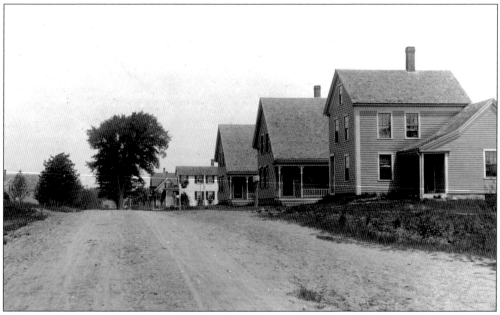

This view of Charles Street from River Street shows a wide graveled roadbed neatly graded. Before the use of blacktop, annual maintenance of the roads required huge amounts of gravel to be procured by the town. If gravel was not naturally available in a given locale, it was bought and transported to the needed area. Note the twin houses on the right of the photograph. (Courtesy of the West Bridgewater Public Library.)

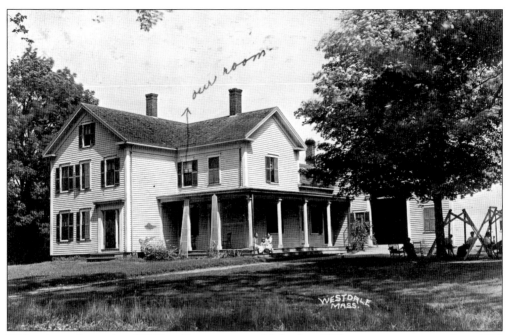

Walnutlawn, located at 320 East Street, was established in 1895 as a country resort. In a 1903 advertisement, owner Frank L. Howland offered his guests "an attractive country estate . . . attractions are croquet, tennis, bicycling, boating and fishing . . . forty-four minutes by express train from Boston." (Courtesy of Richard and Helen Cogswell.)

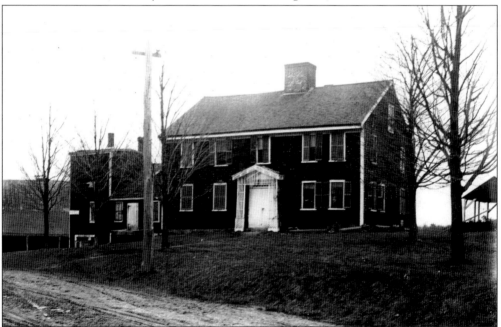

This large house near the corner of Brooks Place and North Elm Street was at one time the home of Addison Brooks, a local market gardener. This section of the town was predominantly farmed by Brooks, along with the Kinney, Copeland, and Snell families. (Courtesy of the West Bridgewater Public Library.)

On October 8, 1911, famous aviator Harry N. Atwood was flying his plane from the Brockton fairgrounds to New Bedford. Hundreds of people along the route turned out for a view of the plane. Developing some type of engine problem, Atwood was forced to land in a field on East Center Street owned by Julius Hayward. Guards were posted at the plane, which remained in the field overnight. Atwood resumed his flight the next day. (Courtesy of the West Bridgewater Public Library.)

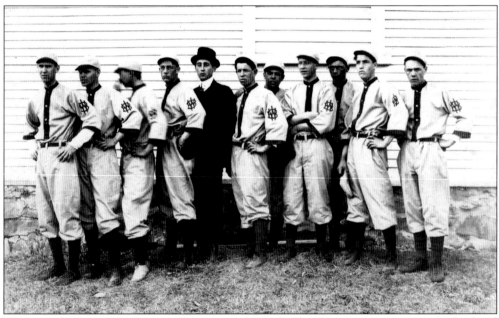

The triangle formed by Spring, Crescent, and North Elm Streets was at one time the local baseball field, and teams such as this well-dressed one from Cochesett gathered for competition. Pictured from left to right are Henry Weston, Wilmer Taylor, Ralph Weston, Willard Peterson, Ralph Ryder (manager), Harold Staples, Roger Keith, Warren Denley, Raymond Burke, Ernest Ferranti, and Earl Lothrop. (Courtesy of the West Bridgewater Public Library.)

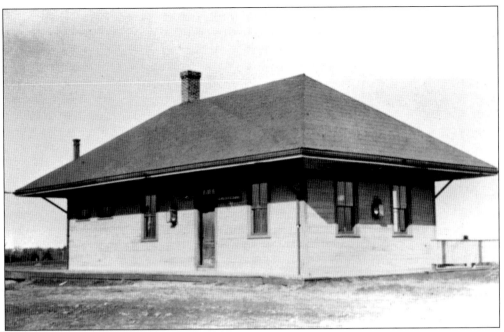

The Cochesett railroad depot on the Old Colony line, which ran from the main line at Matfield to Stoughton, was to the northeast of the intersection of Crescent and West Streets. This spur track crossed over both Spring Street and North Elm Street via iron bridges. Parts of the railroad right-of-way can still be seen behind the high school football field. (Author's collection.)

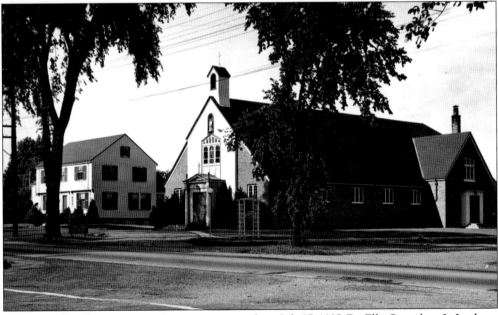

St. Ann's Church was organized as a mission parish on July 27, 1927. Dr. Ellis Sweetlove LeLacheur gave the lot at the corner of Ellis Avenue and West Center Street for the site of the first church. This site proved to be inadequate, and the North Main Street site was purchased. Thomas F. Davock, Frank Ferranti, and John J. Kent Sr. were chosen to head the building committee. (Author's collection.)

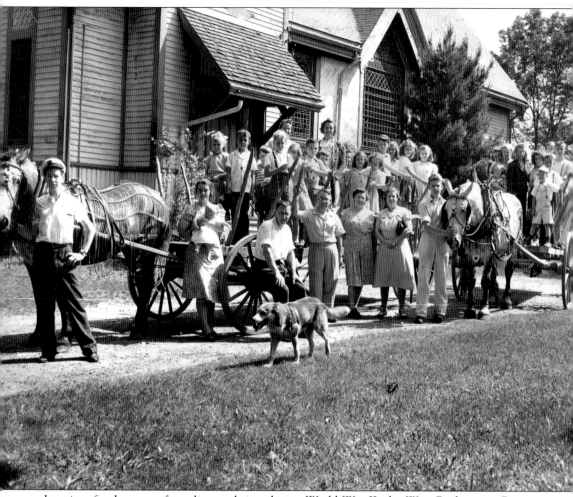

In spite of a shortage of gasoline and tires during World War II, the West Bridgewater Baptist Church Sunday school did not miss out on its annual picnic at Scandia Park in the Campello section of Brockton. Two hayracks transported the gathering to the picnic. From left to right are (with the first wagon) driver Jackie Crowell, Ellen Benson, Betty Benson (baby), Arvid Hagglund, Walter Place, Edith Hambly, Minnie Erickson, Carroll Alexander, Bill MacTighe, Erick Benson, Beattie Gummow, Norman Cogswell, Mickey Hurley, Flora MacTighe, Marilyn Place, Nancy Hemmingway, Nancy Lyseth, Francis Frellick, Millie Hagglund, Janette Gummow, and Edith Erickson; (on the second wagon) Barbara Erickson, Bertil Benson, Bernice Pratt, Charles MacTighe, Bob Place, Margie MacTighe, Claire Hambly, Lucille Berry, Muriel Pillsbury, and Ruth Frellick. (Courtesy of Claire Black and Vera Haskell.)

The West Bridgewater Baptist Church was founded in 1785, and its first building was erected on West Center Street in Cochesett. In 1833, the church dissolved due to lack of interest. It was reorganized in 1835, and a new meetinghouse was built to replace the earlier structure. In 1887, it was voted to move to the center of town, and this edifice was built in 1889 on North Main Street, just south of the town hall. (Author's collection.)

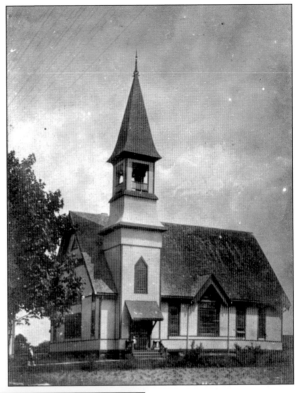

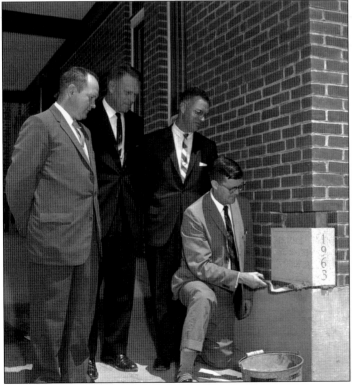

On June 21, 1964, the cornerstone for the new West Bridgewater Baptist Church building on North Elm Street was laid. Pictured here from left to right are William C. Carrigan, chairman of plans; James L. Corbett, chairman of the building committee; Robert D. Howard, building program treasurer; and pastor Henry S. Harding. (Courtesy of the Stonehill College Archives and Historical Collections, Stanley A. Bauman Photograph Collection.)

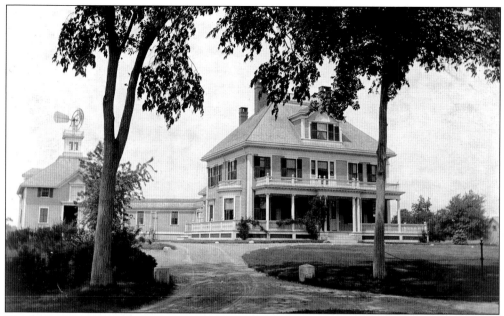

This Victorian manse was built in 1892 by Francis Howard, son of Capt. Benjamin Beal Howard. Francis lived in the house next door built by his father. He donated a portion of the land across from his home for the site of the Old Bridgewater Historical Society building. His daughter, Edith, assumed ownership of the home upon his death and lived out her life there. (Courtesy of Jac MacDonald.)

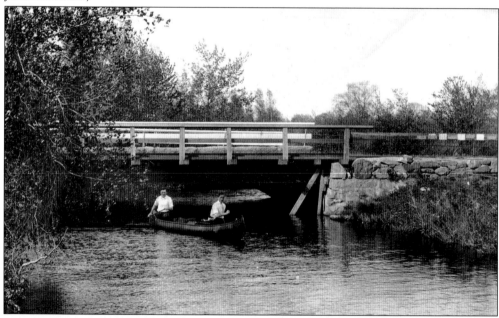

Larkin's Bridge crosses the Town River on South Main Street near Ash Street. Most of these early bridges were of plank and timber construction, later of stone, and then of steel and concrete. Larkin's Bridge was named for Seth Larkin whose farm was by the bridge. It was first made of stone in 1827. Most bridges were maintained by those living the closest to them and benefiting from their use. (Author's collection.)

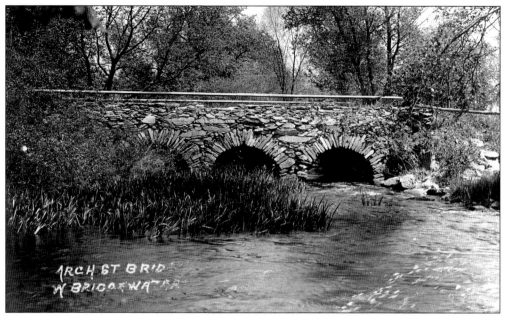

The triple-arch bridge on Arch Street, previously called Osier Street, is of classic keystone construction with dry laid stones being held in place by the weight of neighboring stones pushing on them. This old bridge crosses the Town River just below the dam. The bridge was extensively repaired during the construction of War Memorial Park by local stonemason Algot Benson, a Works Progress Administration foreman on the park project. (Author's collection.)

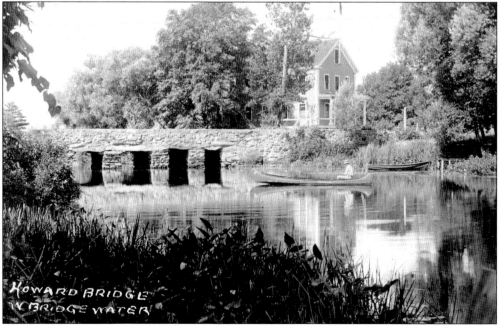

Tavern Bridge, or Howard's Bridge, spans the Town River at South Street across from where John Howard's tavern stood. This was one of the earliest bridge sites in the town. The first bridge, built in 1686, was a timber structure that was replaced with this stone one in 1827. In 2008, a new, modern concrete bridge was built in this place. (Author's collection.)

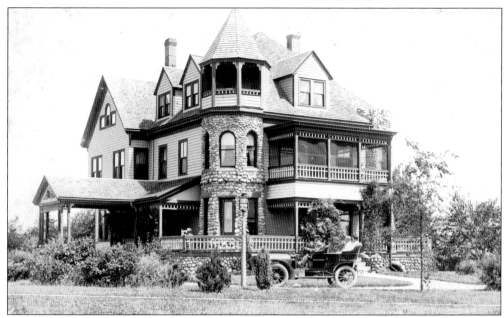

Greystone Towers was built in 1905 by Dr. Ellis Sweetlove LeLacheur as a surgical and maternity hospital. In about 1920, the main use of the facility became that of a sanatorium. The building had 26 rooms and measured 60 by 75 feet. LeLacheur was an 1893 graduate of the Boston University School of Medicine and was house surgeon at the Boston Homeopathic Dispensary. (Author's collection.)

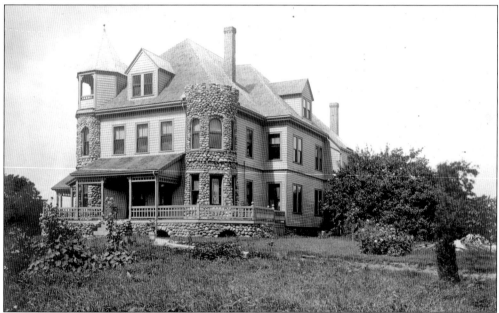

Elegant with its black and white marble floors and massive cobblestone towers, the building burned to the ground on September 16, 1921. The facility was valued at $35,000, the second highest in the town. Ironically, the town's most valuable piece of property, the farm of former state representative Eddy Dunbar, located a stone's through away from Greystone Towers, had burned less than 24 hours earlier, resulting in a loss of $40,000. (Courtesy of Jac MacDonald.)

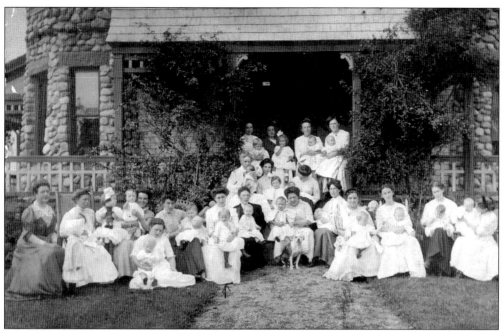

This photograph, taken on the steps of Greystone Towers on Mother's Day in 1914, shows several mothers with their babies, presumably patients of LeLacheur's who were born at his hospital. LeLacheur was the town physician for many years as well as serving on the board of selectmen. His mother, Annie, was chairman of the school board for many years. (Author's collection.)

One of those babies born at Greystone Towers was Erland Williams Thayer on August 15, 1910, at 8:30 p.m. At eight and a quarter pounds, Thayer was a healthy baby and progressed well, as indicated by this one-page diary. It was an exceptional event in the early days when a baby was born in a hospital, as most were born at home, even into the late 1920s and early 1930s. (Courtesy of Duane Thayer.)

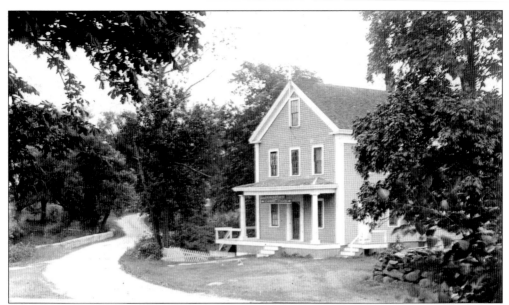

The Nunckatesset Canoe Club stood at the southwest corner of South and River Streets. It was a social organization established for the recreation of local citizens and the executives of the vast number of shoe manufacturers in neighboring Brockton. In operation from the late spring until early fall, canoes could be rented and paddled up and down the river. Many seasons brought loss of life through drowning. This building burned and was replaced with a larger one on the south side of the river. (Courtesy of the West Bridgewater Public Library.)

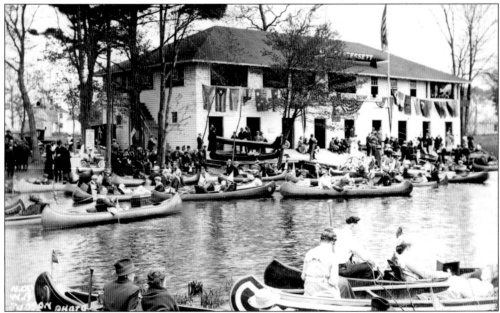

The new, expansive building of the Nunckatesset Canoe Club downstream from the Howard Bridge drew hundreds of local people for canoeing, parties, and other social activities. Note the fancy fashions on many of the canoeists. The Americanage Canoe Club operated on the other side of the river in the Jonathan Howard house. (Courtesy of the West Bridgewater Public Library.)

This view shows the rustic cabinlike interior of a room on the second floor of the Nunckatesset Canoe Club. Complete with piano and mission-style furniture, the room featured access to a balcony with wicker chairs that overlooked the river. Today this building, without its upper story, serves as the Canoe Club Ballroom, hosting many weddings and other gala affairs. (Courtesy of the West Bridgewater Public Library.)

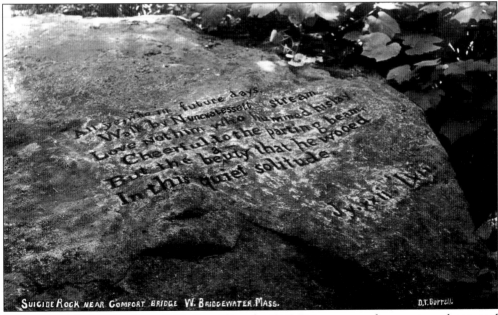

It is presumed that in about 1857, Rev. Timothy Otis Paine, a preacher, poet, sculptor, and scholar from Winslow, Maine, chiseled these words into a platform boulder by Comfort Bridge on Forest Street: "All ye, Who in future days, Walk by Nunckatesset stream, Love not him who hummed his lay, Cheerful to the parting beam, But the Beauty that he wooed, In this quiet solitude." (Author's collection.)

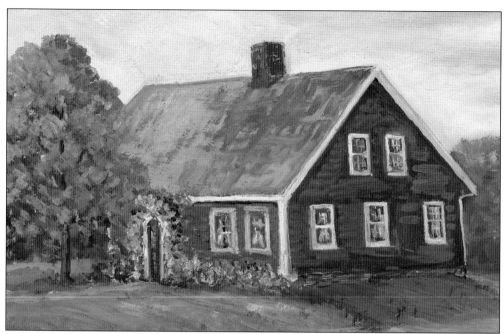

This 1932 painting by Brockton artist Victor Lawson shows the early-18th-century farmhouse located at 530 Manley Street. In the late 19th and 20th centuries, this was part of a farm owned and operated by a succession of Swedish immigrant farmers, Lars Eklund, Reuben Mattson, and Adolph Johnson, and lastly by one of the few woman dairy farmers in the region, Walborg Axelina Johnson. (Author's collection.)

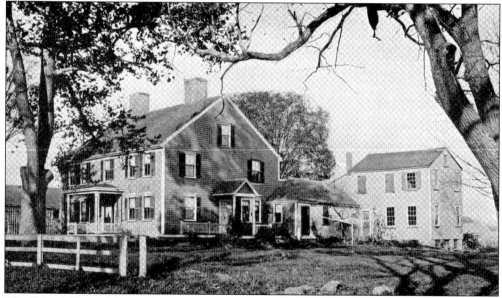

The Daniel Howard house, built in 1795 on South Street, was considered the most beautiful house in all of Bridgewater. It was in this home that the great poet William Cullen Bryant studied law under William Baylies. Baylies served in the Massachusetts house and senate and was a member of the U.S. House of Representatives from 1813 to 1817 and 1833 to 1835. (W. W. Bolton Photograph from *Descendants of John Howard* by Heman Howard.)

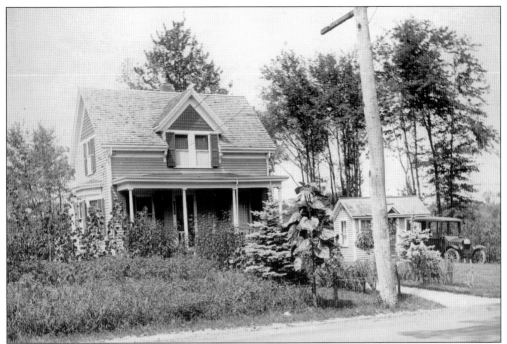

Built in 1917 by Nova Scotia native and local charcoal merchant and home builder Sidney Barr, this house at 690 North Main Street was purchased by P. Eric and Gerda Bergstrom in 1920 when the road, now Route 28, was still dirt. The home's location in a swampy area earned Bergstrom the moniker "Swamp Eric" among the Campello Swedes. Bergstrom's son, Harold, was among the region's finest woodworkers. (Courtesy of Gladys Bergstrom.)

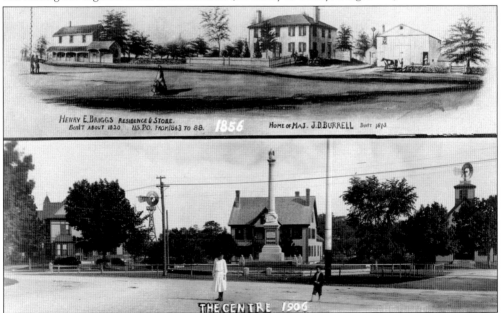

This postcard view shows what the center of West Bridgewater looked like in 1856 as compared to 1906. In the 1906 image, notice the windmills on the Gibson farm on the right and another on the left. The Gibson family farm was basically in the village center. (Author's collection.)

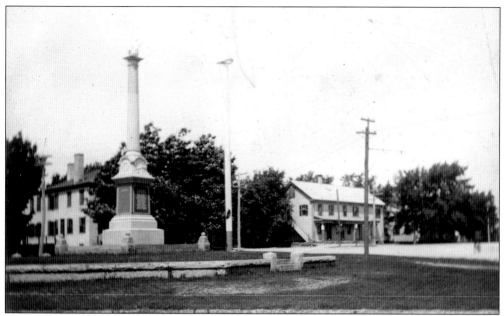

Central Square, or Monument Square, is at the confluence of what are Routes 106 and 28 today. The Burrell home on the left of the monument is now gone; however, the former store of George Drake remains. Other old homes that surrounded the square have also succumbed to modernization and roadway expansion. The corporate icons and heavy traffic flow of today have given this area a new look. (Courtesy of Jac MacDonald.)

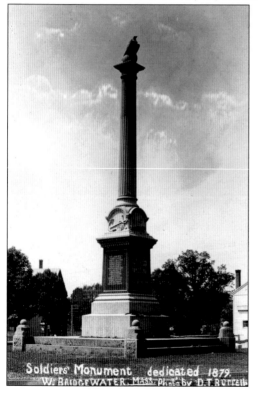

Soldiers' Monument dedicated 1879.
W. BRIDGEWATER MASS. Photo by D. T. Rorrell

Dedicated on July 4, 1879, the soldier's monument was presented to the town by Francis E. Howard who represented the monument association. On November 7, 1865, townspeople had organized an association to build a fitting monument to those who died in the Civil War. The monument is 35 feet high, weighs 70 tons, and was built at a cost of $3,500. It is made from Quincy granite and granite from Clark's Island, Maine. (Author's collection.)

The center of West Bridgewater was the home to Massachusetts State Police regional barracks. This farmhouse on Central Square was converted into such use and also served as the town's civil defense headquarters in World War II when it was manned 24 hours a day by volunteer watchmen. Remnants of the granite curbing surrounding the property can still be seen at the southeast end of the square. (Author's collection.)

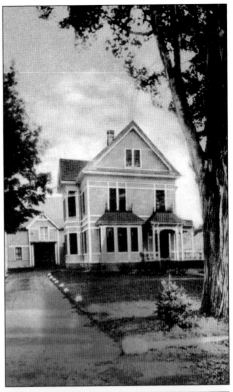

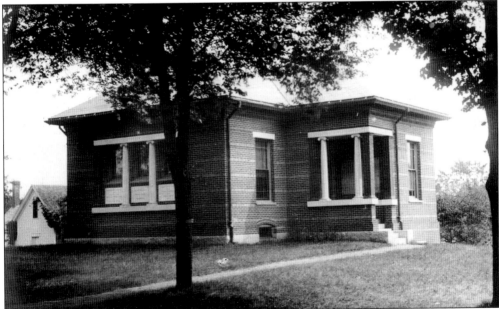

The Old Bridgewater Historical Society was organized on April 19, 1894, and incorporated on July 18, 1895. In 1900, the building pictured here on Howard Street was dedicated to the memory of the original proprietors of Old Bridgewater. Erected on land contiguous with the first meetinghouse and first burying ground, the building was made possible due to the munificence of Francis Edward Howard. (Author's collection.)

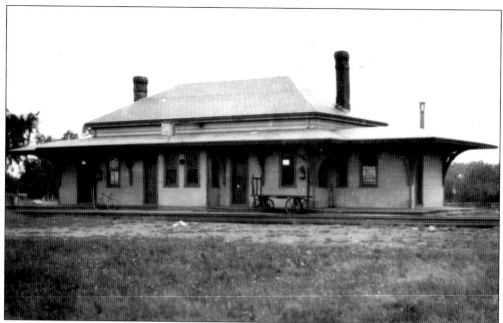

The West Bridgewater railroad station was located off North Main Street behind First Church where the component building and Turner Steel are located. This location was also a freight depot and siding for the West Bridgewater Grain Company. This was the first stop off the main line of the Old Colony railroad. On weekdays in 1890, this station saw six passenger trains go in each direction. (Author's collection.)

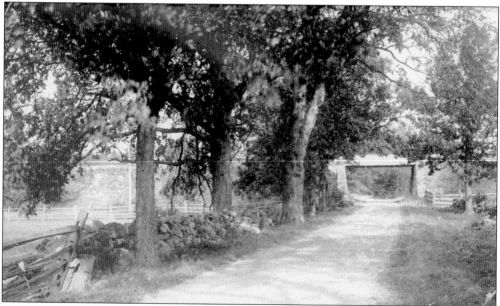

The Old Colony railroad spur track that ran from Matfield to Stoughton crossed over both Spring Street and North Elm Street on iron girder bridges. This image shows the Spring Street bridge, which was located just north of where the Spring Street School is today. The railroad bed from this point to beyond North Elm Street was a large built-up mound, as seen on the left of the photograph. (Courtesy of Jerry Lawrence.)

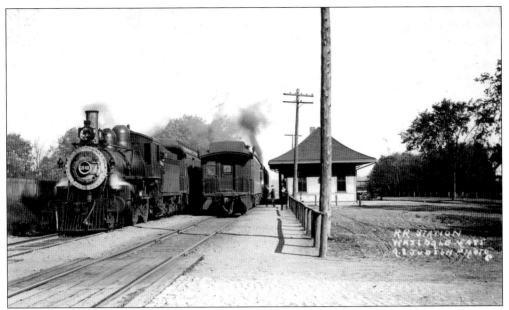

The Westdale station was physically in East Bridgewater but known as the East and West Bridgewater station. Westdale is located where the center tree marker stands, identifying the geographical center of old Bridgewater. In 1890, this station saw 30 passenger trains a day pass through—14 northbound and 16 southbound. (Author's collection.)

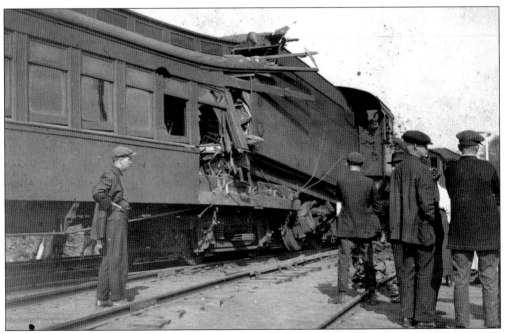

At 6:40 a.m. on October 7, 1921, two Boston-bound trains collided at Westdale. The express train was from Middleboro, and the other was out of Campello, heading south on the Panhandle line through East Bridgewater. As the Campello train was crossing over the track at Westdale, the express came around the curve, and in dense fog, they collided head on. (Courtesy of Wayne Eldridge.)

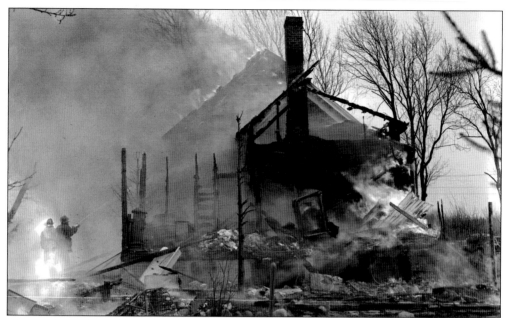

On April 1, 1947, a fire began in the barn attached to the home owned by the estate of William F. Ryder that was occupied by Mabel Nelson, located just north of the present Riverbend Golf Course clubhouse. High winds caused the fire to spread quickly across the street to a home owned by Mildred Bluis. (Courtesy of the Stonehill College Archives and Historical Collections, Stanley A. Bauman Photograph Collection.)

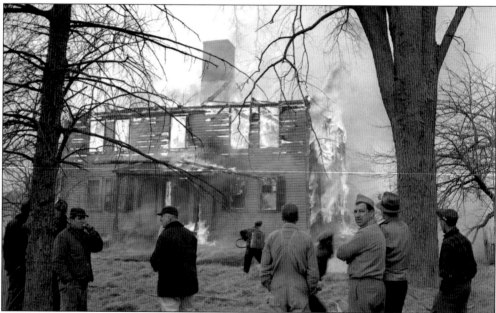

The 10-room Colonial farmhouse of Bluis caught fire quickly, as wind carried embers across the street to the wood-shingled roof. Fire Chief Edward Bourne blamed the loss of both the Nelson and Bluis homes on low water pressure, a problem that was revisited in 1949 when the Howard High School fire occurred. (Courtesy of the Stonehill College Archives and Historical Collections, Stanley A. Bauman Photograph Collection.)

Knowing that water pressure was of concern, the town constructed a water standpipe off Sunset Avenue, which was scheduled to be in service on July 1, 1949. The new standpipe stored nearly a half million gallons of water. This project was completed at a cost of approximately $208,000. At the time, West Bridgewater drew water from 32 driven wells. (Courtesy of the Stonehill College Archives and Historical Collections, Stanley A. Bauman Photograph Collection.)

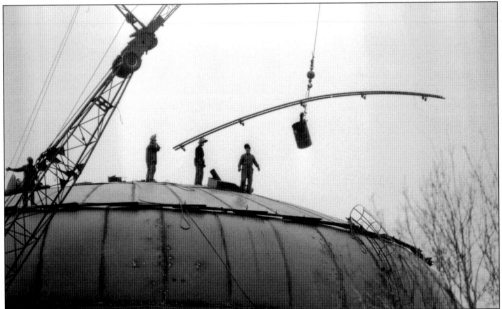

In 1972, workmen were putting the finishing touches on a second water storage facility located next to the existing standpipe. The new structure provided the town with a much-needed increase in storage as well as pressure to accommodate new industry and housing being built in the town. (Courtesy of the Stonehill College Archives and Historical Collections, Stanley A. Bauman Photograph Collection.)

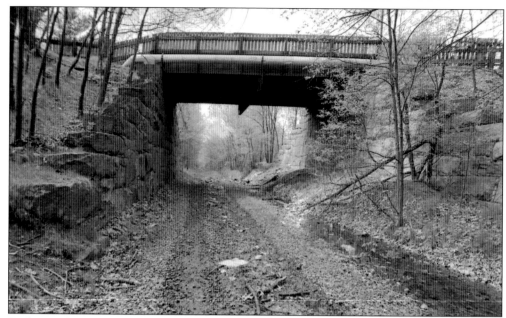

Bridges such as this iron girder one on East Street carried vehicular traffic over the railroad. Abandoned for many years with the tracks removed, these bridges continued to require maintenance. In 1973, the East Street bridge was deemed unsafe and closed. Rather than repair the bridge, it was removed, and the chasm was filled and paved across. (Courtesy of the Stonehill College Archives and Historical Collections, Stanley A. Bauman Photograph Collection.)

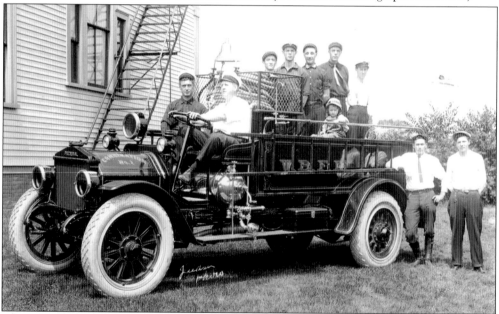

This is the West Bridgewater Fire Department on Combination 1 manufactured by Federal. Cecil Andre is at the wheel with William Gibson beside him. Others from left to right are Edward Bourne, Fred Beers, Harry Hatch, Henry Howard, Winnie Sands, George Gaskill, and Wallace Hefler. The young future firefighter on the engine is Fred Beers's three-year-old son. (Courtesy of the West Bridgewater Public Library.)

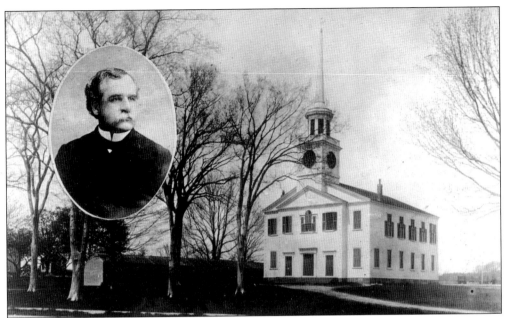

First Church, located on Howard Street, was gathered in 1651, and in 1662, it called James Keith of Scotland as its first minister. The church's first building was a small log structure used until 1671 when a larger one was erected. A third meetinghouse was erected in 1750, and the present structure, pictured here with a photograph of Rev. E. B. Maglathlin, was built in 1801. (Author's collection.)

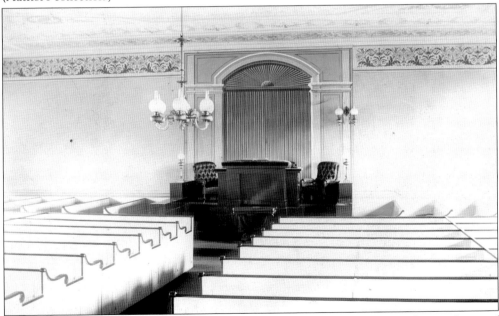

This view shows the simple Colonial interior as it looked in the late 1890s. The parish was of Congregational affiliation until 1825, when it became a member of the American Unitarian Association until 1954. It then united with the Sunset Avenue Congregational Church. Only three ministers served the church in its first 169 years: James Keith, Daniel Perkins, and John Reed. (W. W. Bolton Photograph from *Descendants of John Howard* by Heman Howard.)

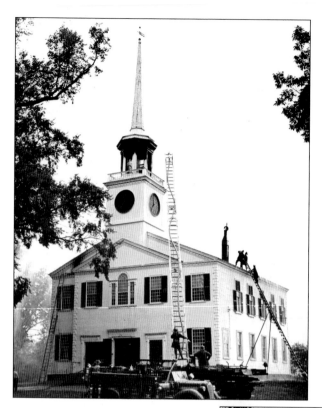

In August 1951, the spire atop the clock tower on the First Church on Howard Street was struck by lightning. Quick action by the West Bridgewater Fire Department prevented flames from spreading to the main structure of the ancient church building, erected in 1801. (Courtesy of the West Bridgewater Public Library.)

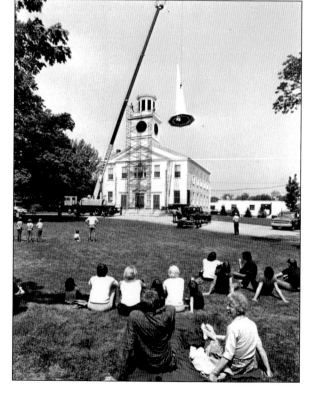

After almost a quarter of a century without its steeple, the First Church received a new prefabricated steeple in 1975. In this photograph taken on May 23, several onlookers watch as the new steeple is raised into place. The steeple was surmounted with a weather vane designed by Karen Turner in the stylized form of a fish, an ancient Christian symbol. (Courtesy of First Church.)

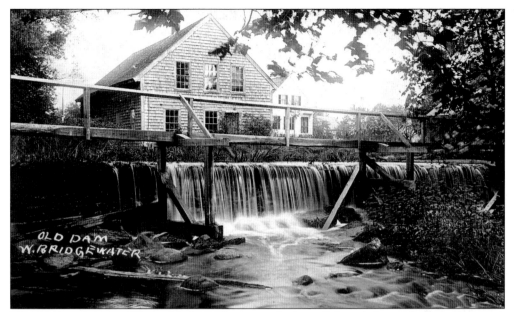

The dam on the Nunckatesset or Town River was built in Colonial days to harness the river's waters into a usable supply for the various manufacturing operations that took place at what is today War Memorial Park. Depending on the constant flow of water were a shingle mill, a lumber mill, and the shovel works of the Ames family. (Author's collection.)

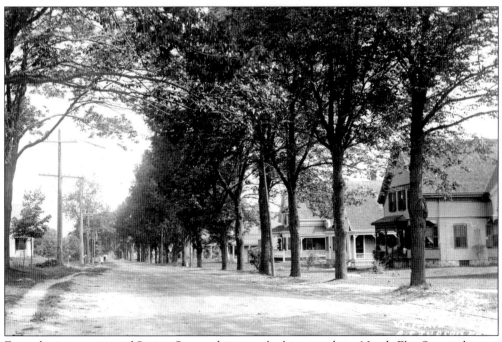

From the intersection of Spring Street, this view, looking north up North Elm Street, shows a tree-lined country road with well-maintained homes. Even though the roads were gravel, many such as this one had sidewalks as well to keep pedestrian traffic out of harm's way. (Courtesy of the West Bridgewater Public Library.)

✦ Order of Exercises ✦

FOR THE OBSERVANCE OF MEMORIAL DAY,

BY POST 202 AND W. R. C. NO. 168.

— AT —

WEST BRIDGEWATER,

1895.

The pains of the Civil War were very real in the decades following the war, and most towns held long and elaborate celebrations honoring those who served and those who died. The local post of the Grand Army of the Republic held such an event on Memorial Day in 1895. (Author's collection.)

The Post will take the 6.18 A. M. train for Cochesett, where, escorted by the School Children and Band, they will march to Pleasant Hill Cemetery.

Exercises at Pleasant Hill Cemetery.

DIRGE.	By the Band.
MEMORIAL SERVICE BY POST 202.	
PRAYER.	Rev. E. S. Hammond.
MEMORIAL HYMN.	Quartette.
ADDRESS.	J. A. Shores, Esq.
DECORATION OF THE GRAVES OF SOLDIERS AND SAILORS BY THE SCHOOL CHILDREN.	
AMERICA.	School Children and Audience.
BENEDICTION.	Rev. E. S. Hammond.

At the conclusion of the exercises at the Cemetery, the Post and Band, at the invitation of the ladies of Cochesett, will proceed to the vestry of the Methodist Church, where breakfast will be served.

The Post will return to West Bridgewater by the 9.26 A. M. train and proceeding to Pine Hill Cemetery will decorate the soldiers' and sailors' graves there.

A Collation will be served at 12 o'clock, noon, to the Post, Band and invited guests, at Town Hall, by the ladies of W. R. C. No. 168.

Programme at the Monument.

AT 2 O'CLOCK P. M.

MUSIC.	By the Band.
PRAYER.	Post Chaplain.
MUSIC.	By the Band.
CALLING THE ROLL OF HONOR.	S. V. Commander.
RESPONSE.	Post Adjutant.
DEPOSIT OF FLORAL OFFERINGS.	School Children.
MUSIC.	By the Band.
ADDRESS.	Rev. E. M. Bartlett.
MUSIC.	By the Band.

Programme at the Town Hall.

MUSIC.	By the Band.
MEMORIAL SERVICE OF THE G. A. R.	
MUSIC.	By the Band.
ORATION.	Comrade Henry Hiatt.
MUSIC.	By the Band.
AMERICA.	Sung by the Audience.
BENEDICTION.	

The program for the 1895 observance indicates three significant gatherings of remembrance that began at 6:18 a.m. by taking the train to Cochesett. Schoolchildren were a big part of these sacred celebrations. The main gathering took place at 2:00 p.m. at the Civil War monument in the center. At the monument, it was a tradition to read the names of the dead and where they died. (Author's collection.)

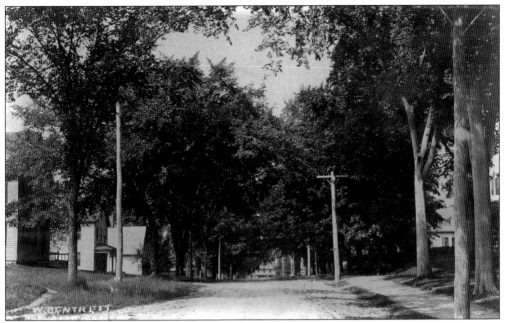

This view is of West Center Street (Route 106) from the corner of Lincoln Street in Cochesett looking west. The construction of Route 24 in the 1950s changed much of the tranquility of the small village and resulted in the destruction of many old and stately homes and industry. Cochesett was once home to the shoe manufactory of Edward Tisdale and Sons. (Courtesy of Karolyn Boyd.)

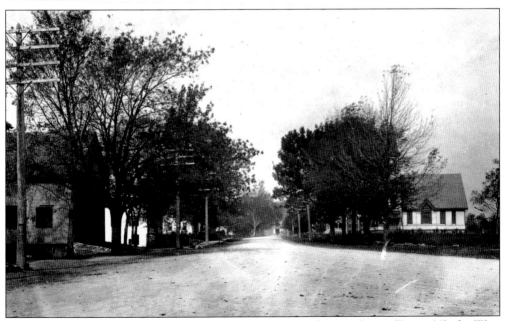

In this view looking north from Monument Square up North Main Street (Route 28), the West Bridgewater Baptist Church is on the right-hand side of the image. While in the state legislature, Orvis Kinney was instrumental in having Route 28 come through West Bridgewater when it was being constructed as the major route of travel from Boston to Cape Cod. (Author's collection.)

War Memorial Park, or the town park, located on River Street, is considered to be the first industrial park in America. Many varied industries were grouped here to take advantage of the waterpower. The giant millstone serves as a reminder that it was on this site where Deacon Samuel Edson established the first gristmill in 1662. (Author's collection.)

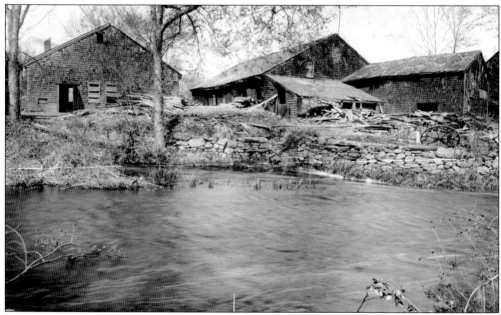

The old forge buildings of the Ames Shovel Company backed up to the Town River. During the Great Depression, as a Works Progress Administration project under the direction of Eveline C. Johnson, the old industrial center of the town was reclaimed as War Memorial Park and dedicated to world peace in 1936. In 2008, the park was listed on the National Register of Historic Places. (Author's collection.)

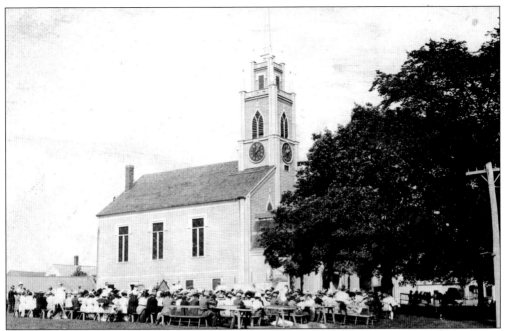

In 1806, the first Methodist services were held in Cochesett at the home of George Howard. The congregation officially organized in 1832 and received its first pastor, I. J. P. Colloyer, in 1841. In 1844, the current church building was constructed at a cost of $2,468 and funded by Caleb Howard. The building was raised in 1888, and the lower floor was built underneath. (Courtesy of Karolyn Boyd.)

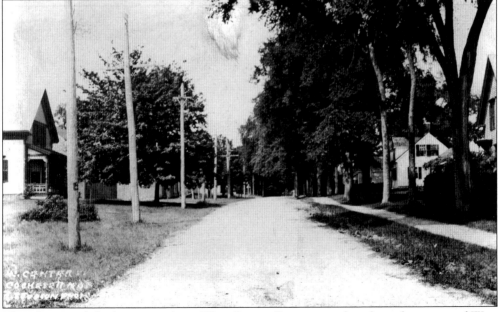

This photograph looking west down West Center Street was taken from the corner of West Street. The first home on the left is the home of David and Marilyn Raleigh today. The barn to the right of the house is now the location of Dempsey's Village Barn. (Courtesy of Karolyn Boyd.)

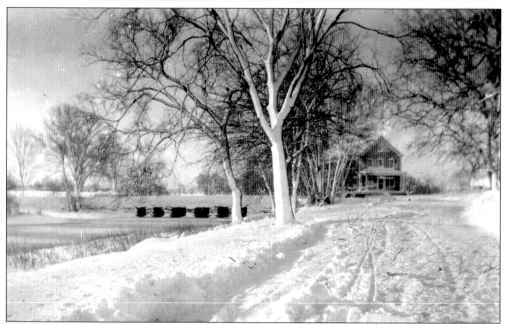

This picturesque winter view of River Street is looking from the town park toward the old Nunckatesset Canoe Club. In the era before snowplows, local residents were responsible for removing the snow from the roads by their property with their own horse- or oxen-drawn equipment. (Author's collection.)

OLD HOME WEEK
and Brotherhood Carnival

COCHESETT, MASS.
SEPT. 4 = 5 = 6, 1909.

Local celebrations were important to the social life and well-being of the community, and with the advent of advertising media such as this postcard, these events were well publicized. This 1909 postcard is an advertising piece aimed at attracting people to attend old home week in Cochesett. (Author's collection.)

BIBLIOGRAPHY

Committee of Arrangements. *Celebration of the Two Hundredth Anniversary of the Incorporation of Bridgewater, Massachusetts.* Boston, MA: John Wilson and Son, 1856.

Howard, Heman. *The Howard Genealogy.* Brockton, MA: The Standard Printing Company, 1903.

Hurd, D. Hamilton. *History of Plymouth County, Massachusetts, with Biographical Sketches.* Philadelphia, PA: J. W. Lewis & Company, 1884.

Mitchell, Nahum. *Mitchell's History of Bridgewater, Massachusetts.* Bridgewater, MA: Henry T. Pratt, Printer, 1897.

Old Bridgewater Historical Society. *History of West Bridgewater.* Taunton, MA: William S. Sullwold Publishing, Inc., 1986.

Old Bridgewater Historical Society. *Old Bridgewater Tercentenary.* Brockton, MA: Standard Print, Inc., 1956.

Across America, People are Discovering Something Wonderful. Their Heritage.

Arcadia Publishing is the leading local history publisher in the United States. With more than 3,000 titles in print and hundreds of new titles released every year, Arcadia has extensive specialized experience chronicling the history of communities and celebrating America's hidden stories, bringing to life the people, places, and events from the past. To discover the history of other communities across the nation, please visit:

www.arcadiapublishing.com

Customized search tools allow you to find regional history books about the town where you grew up, the cities where your friends and family live, the town where your parents met, or even that retirement spot you've been dreaming about.